IMAGES
of America

DIXVILLE,
COLEBROOK, COLUMBIA,
AND STEWARTSTOWN

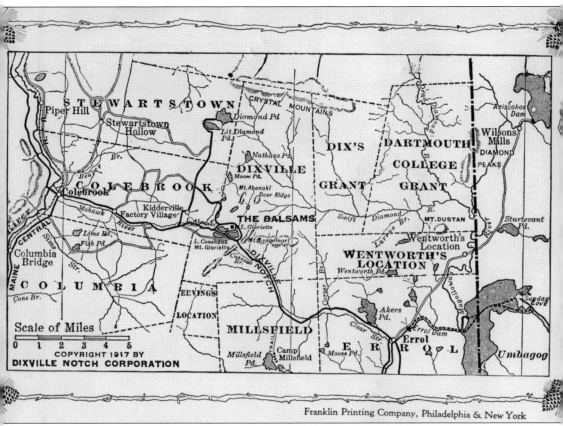

Franklin Printing Company, Philadelphia & New York

This 1917 map by the Dixville Notch Corporation shows the four towns of Dixville, Colebrook, Columbia, and Stewartstown, New Hampshire, just below the United States–Canada border. The Mohawk River slices across to join the Connecticut River (in the west), which is flanked by the Maine Central Railroad and the state of Vermont. (CHS.)

ON THE COVER: The waitstaff of the Balsams Grand Resort pose in front of the hotel entrance in 1938 with what appears to be their mascot pooch. They are seated on what became the parking lot. The turrets of the Hampshire House and Dixville Notch serve as a backdrop. (BGR.)

IMAGES
of America

DIXVILLE,
COLEBROOK, COLUMBIA,
AND STEWARTSTOWN

Susan Zizza

ARCADIA
PUBLISHING

Published by Arcadia Publishing
Charleston, South Carolina

Printed in the United States of America

Library of Congress Control Number: 2012944415

For all general information, please contact Arcadia Publishing:
Telephone 843-853-2070
Fax 843-853-0044
E-mail sales@arcadiapublishing.com
For customer service and orders:
Toll-Free 1-888-313-2665

Visit us on the Internet at www.arcadiapublishing.com

*To my mother, Barbara Cross Larssen, whose deep interest in the
history of this region instilled in me from an early age an enduring love
for the people and heritage of New Hampshire's Great North Woods*

CONTENTS

Acknowledgments 6

Introduction 7

1. Dixville 9

2. The Balsams Grand Resort 13

3. Dixville's Tycoon Philanthropist 29

4. Colebrook 37

5. Columbia 63

6. Stewartstown 77

7. Rivers and Railroads 93

8. Sleds and Snowmobiles 111

9. Going to the Movies 121

ACKNOWLEDGMENTS

My thanks go to those who made this book possible by sharing their collections and recollections. It would take volumes to contain all the stories, and volumes to thank all who contributed. It is a deep regret of mine that not all could be included.

The Colebrook Historical Society, the Cohos Historical Society, the Columbia Historical Committee, the Stewartstown Day Committee, and the Canaan, Vermont, Historical Society proved invaluable. Former Regis Paper Company woodland manager Fred Cowan's material on George Van Dyke and the paper companies was also very useful.

The Colebrook Public Library and the Stratford Public Library provided rich resources. Colebrook Library director Julie Colby and her assistants Rose Hand and Cynthia Harris were always ready to assist me with anything I needed. Thanks to Charlie Jordan of the *Colebrook Chronicle* and Karen Ladd of the *News and Sentinel* for their assistance. My appreciation also goes to Justin Eldred, the North Country Chamber of Commerce director. I am grateful to Arcadia Publishing editor Abby Henry and Arcadia staff for their expertise in helping to bring this book to publication. A big debt is owed by me to Rachel Turgeon, who meticulously checked and rechecked my book's layout before submission.

Special thanks go to area historians Nancy Biron, Granvyl "Bud" Hulse, Arnold and Sylvia Goodrum, Bill Schomburg, Ellie Gooch, Leo Mailhot, John Kennedy, Gary Richardson, Emily Haynes, Beverly Uran, Francis Gray, Joan and Fred Cowan, Terrence Rosi, and Lloyd Drew. I am grateful to former Balsams managing partner Steve Barba for his devotion in archiving the Balsams Grand Resort history. I thank past owners and present Balsams Grand Resort owners Daniel Hebert and Daniel Dagesse in sharing these archives. My appreciation to the Neil Tillotson family is immeasurable. The memories and material they shared will honor the visionary who gave so much to his community.

Uppermost is gratitude to my husband, Mark, for his patience in enduring long stretches of my immersion into the past, particularly as his focus is the present. He loves this exceptional place, the Great North Woods, as it is now, challenges and all.

The images in this volume appear courtesy of the collections of the Balsams Grand Resort (BGR); the Canaan, Vermont, Historical Society (CVHS); the Colebrook Historical Society (CHS); the Columbia Historical Committee (CHC); Colebrook Public Library (CPL); Ellie Gooch (EG); Nancy Biron (NB); the Neil Tillotson family (TF); Michael Pearson (MP); Terry Rosi (TR); Beverly Uran (BU); Charles J. Jordan (CJJ); Suzanne Collins (SC); the Colebrook Fire Department (CFD); Gary Richardson (GR); Lloyd Drew (LD); Swift Diamond Riders (SDR); Jenn Landry (JL); Peter Rouleau (PR); the Mabel Caird family (CF); William Weir Sr. (WW); the North American Martyrs Parish (NAMP); the *News and Sentinel* (NS); Marshall Lloyd (ML); Fred Cowan (FC); Lemieux Garage (LG); and Susan Zizza (SZ).

INTRODUCTION

The Native Americans who lived in the far northern reaches of New Hampshire called their land Coash, the spelling of which varies. It is thought to have meant "land of the pine trees." They called themselves the Coashaukes, or "dwellers of the land of the pine trees." The large stands of virgin spruce and white pine are now gone, and Metallak, the last chief of the Abenaki Coashaukes, died long ago, in 1847.

Prior to the American Revolution, King George III encouraged settlement in the remote wilderness of northern New England by giving grants of land to his loyal subjects. Colebrook (Colebrooke-Town), Columbia (Cockburne), and Stewartstown (Stuart) were granted in 1770. The grantees were Sir George Colebrooke, Sir James Cockburne, John Stewart, Esq., all of London, and John Nelson, of Grenada, West Indies. In 1805, following the Revolution, Tom Dix, along with partners Jeremiah Jamal and Daniel Webster, was granted the unincorporated township of Dixville.

Timothy Dix, who had been a colonel in the Revolutionary War, was killed in the War of 1812, fighting the British on Canadian soil. Daniel Webster bought out the interests of the Dix family and his partner, Jeremiah Jamal. Webster then found a family in Rumford, Maine, willing to face the hardships of homesteading in Dixville Notch. This location's only connection to the outside was by means of a rough trail. And so, James and Betsy Whittemore and their three children moved to Dixville in 1812. Betsy died only three years later. By the 1830s, the region was once again uninhabited. Many years later, in 1874, George Parsons of Colebrook put Dixville back on the map when he built the Dix House, the forerunner of the Balsams Grand Resort.

Colebrook is on the confluence of two rivers, the Connecticut and the Mohawk. Its landscape is dominated by Monadnock Mountain, just across the Connecticut River in Vermont. The name Monadnock is thought to come from an Abenaki name referring to an isolated mountain. This solitary mass rises 2,000 feet straight from the valley floor to reach a height of more than 3,000 feet above sea level. The terms of Sir George Colebrooke's 1770 grant involved settling 15 families by January 1, 1772, and 60 families by January 1, 1780. But the Revolutionary War had prevented settlement under the charter terms, and the first settlers arriving after the war took possession by squatter's rights. Colebrook's fortunes changed largely because of its potato starch industry. By 1870, Colebrook was considered the richest town per capita in the state. At its height, 1,600 tons of potato starch left by rail annually. After the decline of the starch industry, the arrival of the railroad in 1887 kept the boom going. Colebrook became the market center of the area, with a thriving main street, a proliferation of industry, and robust tourism.

Columbia, as did the other towns, had little communities within its boundaries. Jordan Hill, Meriden Hill, Cone, Bungy, Tinkerville, and Columbia proper, known as the Valley, were among the distinct "villages within a village." James Lewis opened a tannery in the Valley about 1810, the first in northern Coös County. These communities were often self-sufficient, with stores and churches, and later, granges and a multitude of mills. Gristmills, sawmills, starch mills, and bobbin mills, a cheese factory, and a pearlash—which was used to make soap, glass, and other

products—operation, were just some of the town's industries in the early years. Tourism came naturally to Columbia, which sprouted cabins along the road that wound beside the Connecticut River. Columbia, with its grand vistas, waterways, and cool, clean air, was a magnet to city dwellers seeking relief from the sweltering summer heat. The same could be said of its neighbors, Dixville, Colebrook, and Stewartstown.

In 1799, Daniel Brainard Jr. and others successfully petitioned New Hampshire's general court, requesting that Stewartstown be incorporated, repealing the 1795 incorporation of the formerly named town of Stuart. There was little to brag about when the first town meeting convened in 1800, as it had no stores, shops, or mills and only primitive roads leading to the few log cabins in the area. Still, the bright spot in the view of these early settlers, according to an 1888 report, was the fact that fish and game were plentiful, with no game wardens to keep watch. The dawn of a new century saw a vastly different picture, in part due to lumber baron George Van Dyke and his massive log operations. Van Dyke soon monopolized the timber industry in the area. He also extended the railroad from Colebrook through West Stewartstown to Beecher Falls, Vermont, and into Canada.

The narrow river valleys and thickly forested mountains, many of them higher than 3,000 feet above sea level, have created an environment conducive to a peaceful, healthy way of life. Shopping malls and traffic snarls are not part of the landscape. In fact, there is not one traffic light to be found. Yet, it has enterprising businesses, a modern community recreation center containing an indoor pool and a roller blade/skating rink, a performing arts center, schools, a hospital, and a host of vibrant cultural and sporting events throughout the year. The area draws thousands to its high-country trails, some of which lead directly into the towns. These are maintained by local snowmobile and other off-terrain vehicle clubs. The trails are also open to other recreation, such as dogsledding and hiking.

Conservation efforts have led to the creation of several nature preserves, including the Bunnell Preserve, named in honor of late Columbia attorney and judge Vickie Bunnell. Nash Stream Forest, part of which lies in Columbia, and Coleman State Park, in Stewartstown, are some other areas that remain protected from development. The Cohos Trail, created by Kim Nilsen with the support of others, has allowed visitors and residents to trek into what Nilsen refers to as "the lost high country."

Despite the pressures of modern life, the people of Dixville, Colebrook, Columbia, and Stewartstown remain close-knit. Many know each other by name or at least by sight, and often give a wave of the hand when passing each other's vehicles. This closeness may be attributed, in part, to this region's isolated location, with the Interstate stopping more than 60 miles to the south. Chain stores have their foot in the door, cell towers have sprouted on a few hills, and development is demanding entry, but the Great North Woods remains an extraordinary and relatively unmarred land. It is a place where inhabitants believe themselves fortunate to live and a place outsiders love to visit.

One

DIXVILLE

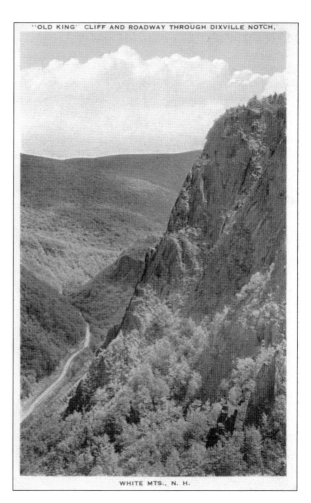

"OLD KING" CLIFF AND ROADWAY THROUGH DIXVILLE NOTCH,

WHITE MTS., N. H.

Dixville's most striking feature, Dixville Notch, is the northernmost opening through the Appalachian White Mountains chain. This east-west passageway was first discovered by the earliest inhabitants of the region, the Abenaki Indians of the Alonquian Confederacy. Later, settlers built a primitive road through the narrow notch, which became Route 26, seen snaking its way along in this 1912 photograph. (CHS.)

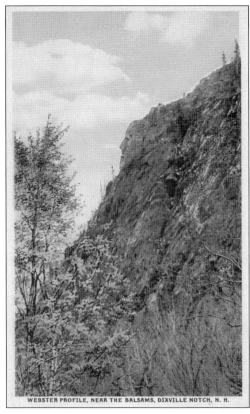

WEBSTER PROFILE, NEAR THE BALSAMS, DIXVILLE NOTCH, N. H.

In 1805, the 31,023-acre unincorporated township that became Dixville was granted to Col. Timothy Dix, the father of Civil War general and New York governor John Dix. Jeremiah Jamal and Daniel Webster cosigned the agreement of nine payments totaling $4,500. When Colonel Dix was killed in the War of 1812, Daniel Webster bought out all the partners. This vintage postcard is an exaggerated depiction of Webster Profile in the Notch. (NB.)

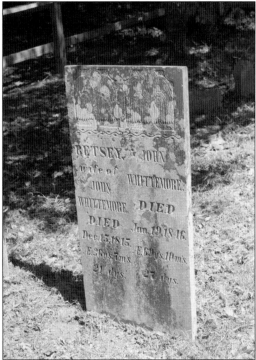

John and Betsy Whittemore's gravesite is east of the Notch, near Huntington Cascade on the south side of Route 26. Hired by Ezekiel and Daniel Webster, attorneys for Colonel Dix, they moved with their three children, Benjamin, Sarah, and Mary, to Dixville in 1812. They built a farm on the site where they are now buried. It became a wayside inn when traffic increased after a road was built. (SZ.)

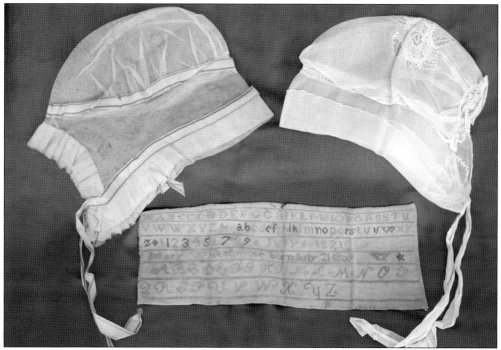

John Whittemore's great-great-great-great grandson, William Weir Sr., of Weir Christmas Tree Farms in Colebrook, owns the sampler above, created by John and Betsy Whittemore's daughter Mary when she was 12, as well as a Whittemore child's day bonnet and night cap. Betsy survived only three years of Dixville homesteading, dying at the age of 36 in December 1815. (SZ.)

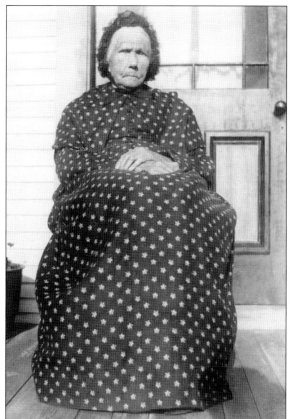

Mary Titus Hodge, the maternal great-grandmother of Balsams owner Neil Tillotson, was another early settler in Dixville Notch. A full-blooded Abenaki, she and her husband, David (1802–1876), settled just west of the Notch, where longtime Dixville resident Frank Nash later raised a family. The Hodges moved to East Hereford, Quebec, where Neil Tillotson was born. The 2010 United States census shows Dixville Notch having a total population of 10 people. (BGR.)

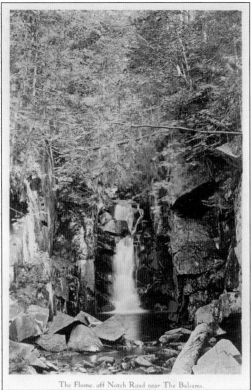

The Flume, off Notch Road near The Balsams.

The Flume, seen in this 1917 photograph, is a waterfall on Route 26's northern side, a short distance from Huntingdon Cascade. It is one of Dixville's many natural attractions, among them the Mohawk and Swift Diamond Rivers, Mud Pond, and Dixville Peak. From Dixville Peak's 3,382-foot summit, a hiker or snowmobiler can see into Vermont, Maine, and even Canada. It is part of the 162-mile Cohos Trail. (CPL.)

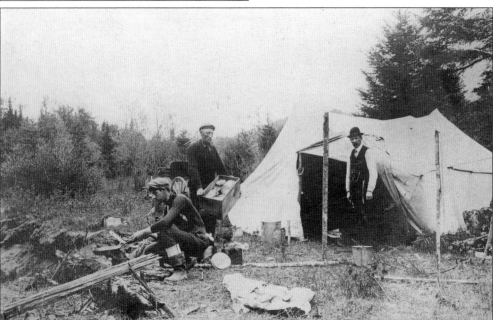

In this 1908 photograph, Nelson Ladd sets up camp for city sportsmen looking for a wilderness adventure. The renowned guide routinely met clients at the Colebrook train station with his matched team of dappled horses, driving them and their equipment into the forested depths of Dixville and beyond. One three-day guided trip netted 40 pounds of dressed trout. (SZ.)

Two

The Balsams Grand Resort

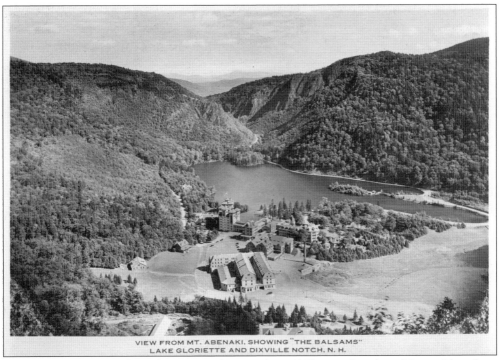

VIEW FROM MT. ABENAKI, SHOWING "THE BALSAMS"
LAKE GLORIETTE AND DIXVILLE NOTCH, N. H.

This bird's-eye view of the Balsams Grand Resort from 1917 was taken from Mount Abenaki, a nesting place of the rare peregrine falcon. The century-old historic hotel sits on the shore of Lake Gloriette, facing east into Dixville Notch. The Mohawk River begins at Lake Gloriette, which is fed by Lake Abenaki and Mud Pond. (CPL.)

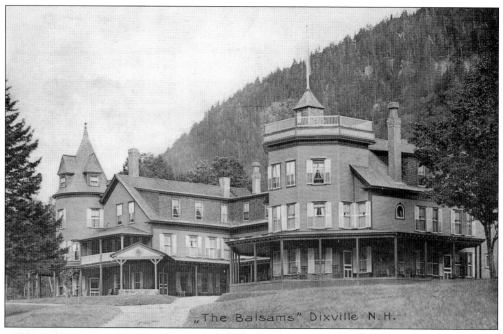

"The Balsams" Dixville N.H.

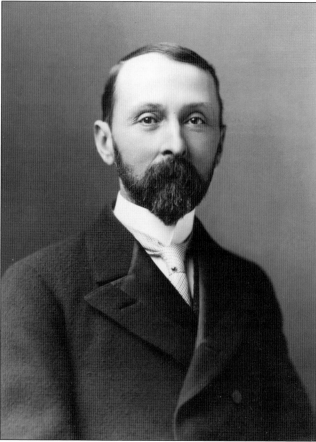

Frank Walker was the first to build an inn on this site in 1864, but it burned down two weeks later. George Parsons of Colebrook built the Dix House in 1874. The first dining room was on the ground floor on the right, with the John Dix Room to the left, as seen in the 1912 image above. (NB.)

After George Parsons died in the 1890s, his wife, Clara, sold the hotel to one of her guests, Henry Stafford Hale (pictured). Hale renamed it the Balsams, partly as a marketing tool. Advertising its abundance of balsam firs helped promote the summer resort as a mountain-fresh and hay fever-free environment. The hotel's logo, with three balsam firs, sprung from the idea. (BGR.)

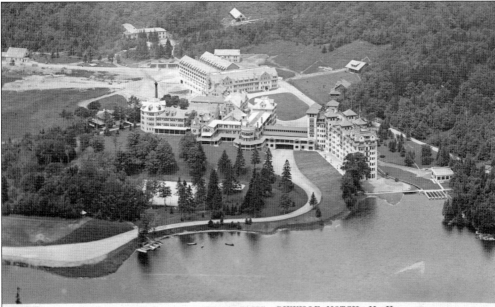

LAKE GLORIETTE AND THE BALSAMS—DIXVILLE NOTCH, N. H.

Henry Hale added the ballroom wing and the Hampshire House, seen in the 1918 image above. Other additions included his residence, adjacent to the west wing, which later became the Wind Whistle, for guests' children and their nannies. He also built Beaver Lodge, which later became the Balsams Culinary Apprenticeship School, and the Captain's Cottage. He put in three lakes, the Gloriette, the Coashauk (now the lower golf course), and the Abenaki, the uppermost reservoir. (NB.)

Due to bad investments, Hale was eventually forced to sell his hotel to Joseph Lannin, a Canadian-born hotelier. Lannin used the $800,000 from his sale of the Boston Red Sox to purchase the Balsams in 1918. Lannin, in turn, traded hotels with Capt. Frank Doudera (pictured) in 1927 after a few friendly drinks at a New York City bar. No money was exchanged in the deal. (BGR.)

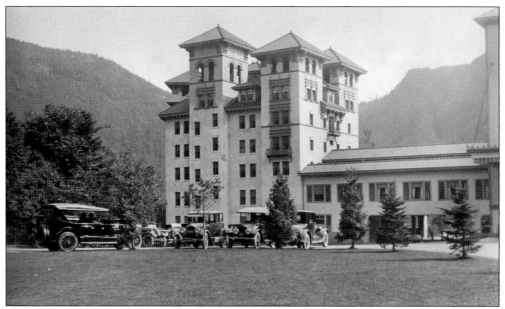

Here, guests' automobiles await delivery to the garage around back. The driveway once passed through the portico under the dining room. Upon a guest's arrival, a doorman would transport the automobile to the garage, then race back through tunnels under the hotel. How the man was able to return to his station so speedily remained a mystery to guests. (BGR.)

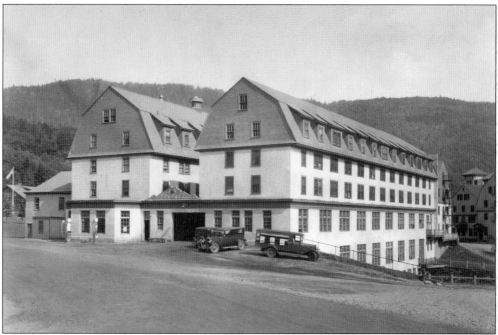

These buildings began as horse barns and were upgraded to garages, as seen in this 1918 photograph. In the 1950s, the buildings were converted to factory space by Neil Tillotson, for making Parker Pen ink sacs, among other products. The operation initially employed eight local women, including Lucinda Cross, who called themselves the Parker Pen Girls. The buildings were demolished in the autumn of 2012. (BGR.)

The chauffeurs lived above the garage. These quarters served as a staff dormitory into the 1960s. The eaves once held a staff dance hall, and the cellar held a bowling alley. Retired Colebrook teacher Terry Rosi, who first worked as a caddy and then in the dining room, attended the Balsams Grand Resort auction in May 2012 and saw his initials still visible in the room he had occupied. (BGR.)

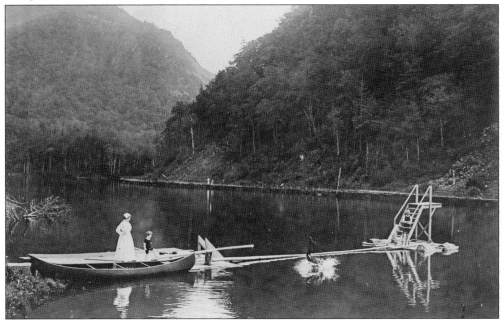

A nanny and her charge watch another child jump into the water at what was referred to as the swimming pool, near the dam end of Lake Gloriette. Out of sight on the left in this 1918 photograph are two bathhouses where swimmers could change clothes. An outdoor pool for guests was built in 1955. (CPL.)

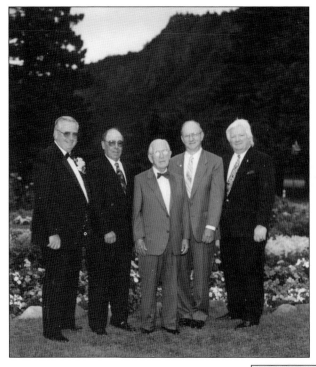

Neil Tillotson attended the 1954 Balsams bankruptcy auction and purchased the hotel as the only bidder. In 1971, after management companies had failed, Tillotson selected four trusted employees, who turned the struggling resort around. They formed the Balsams Corporation in 1976. This 1995 photograph shows the managing partners, from left to right, Warren Pearson, Raoul Jolin, Neil Tillotson, Philip Learned, and Stephen Barba. By the 1990s, the resort employed more than 700 people. (MP.)

Tillotson had the springhouse rebuilt in 1994. The original structure was gone when he purchased the hotel, but he remembered driving to the Balsams from his home in Beecher Falls, Vermont, with his parents, a four-hour trip. In a childhood memory, Tillotson recalls drinking from the spring and turning and seeing the Balsams through the trees. This water was later bottled and sold through VeryFine. (CHS.)

COLD SPRING AND THE BUTTRESS, NEAR THE BALSAMS.

DIXVILLE NOTCH, N. H.

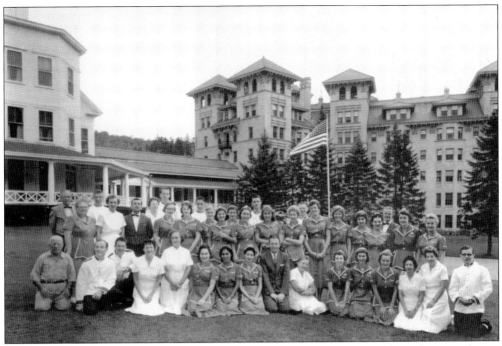

This photograph is likely a composite of Balsams staff, with maintenance, housekeeping, dining room, and kitchen personnel represented. They are sitting on the lake side of the hotel, where the driveway used to pass through the portico. The Dix House is to the left and the Hampshire House is to the right. (BGR.)

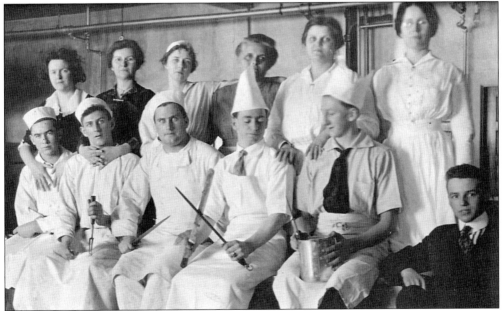

The kitchen brigade of 1916 looks rather intimidating in this play-acting pose before the camera. The kitchen and staff dining room was located where the modern-day staff canteen was placed. George Parsons had the kitchen initially built separately from the hotel, in a wise move to prevent a fire spreading. (BGR.)

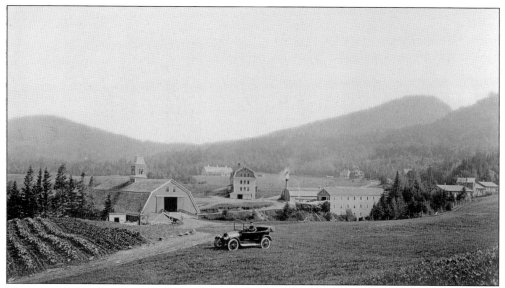

The hotel had 16 farms, with a large Holstein herd and Jersey shorthorn cattle, swine, and draft horses. It also had a deer park, where the Captain's Cottage, managing partner Warren Pearson's longtime residence, is now. While the farms raised local produce for the hotel, there was an era when a plane would land each day bringing three important items: newspapers, fresh seafood, and flowers for the dining room. (CPL.)

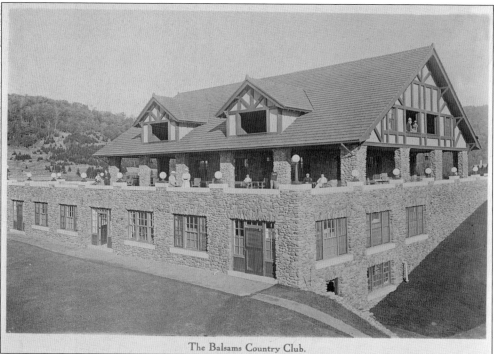

The Balsams Country Club.

In 1902, the Balsams Country Club was built on the upper Panorama Golf Course, which was designed by famed golf course architect Donald Ross. The wraparound clubhouse deck provides stunning views of Dixville Notch to the east and the mountains and valleys to the west. The Balsams sheep once grazed on the golf course, keeping the turf closely cropped. (CPL.)

Oxcarts hauled the stones for the clubhouse from the Androscoggin River. Each stone was placed in a box lined with hay to prevent damage during the trip. When the roof required repair in the 1990s, the company that provided the original roof tiles, which was still in existence, was called upon to do the repair work. (CVPL.)

The Balsams Country Club has hosted many a gala occasion over the years, with live music and dancing. Up until it closed in the fall of 2011, the dining room served lunch to golfers and others who made the drive up from the hotel to enjoy fine food and the panoramic view. (TF.)

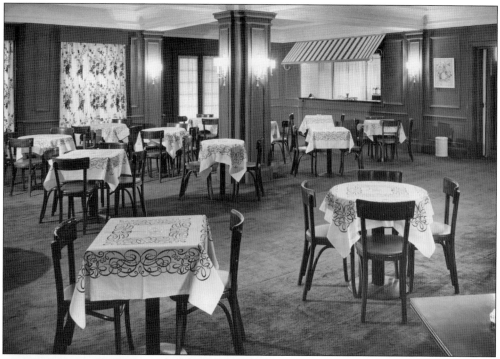

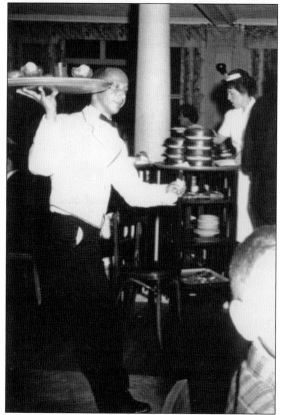

The room above, off the lobby, was known from the 1920s until 1966 as the Rendez-Vous Room. It later became the Wilderness Room, and then the Tavern. The dining room upstairs had elegant fare, created by some of the finest chefs to be found. The Balsams Apprenticeship Culinary School, established by chef Phil Learned in Beaver Lodge in 1978, graduated many accredited chefs over the years. (TF.)

During the summers of 1959 and 1960, Harris Webber, a student at Temple University, served as a breakfast room server. Servers had to step lively and became adept at carrying heavy trays swiftly through the expansive dining room and hallways. Webber had obviously mastered the technique here, demonstrating a cheerful, confident stride. (TF.)

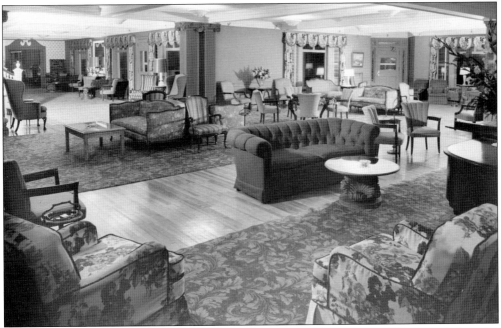

The John Dix Room featured a cocktail social every Monday evening. The room led to the sunroom, ballroom, billiard room, and ballot room in one direction, and to the dining room, guest rooms, and lobby in another. A door also led outside to the wraparound porch and the steps leading down to the tennis courts and pool. (TF.)

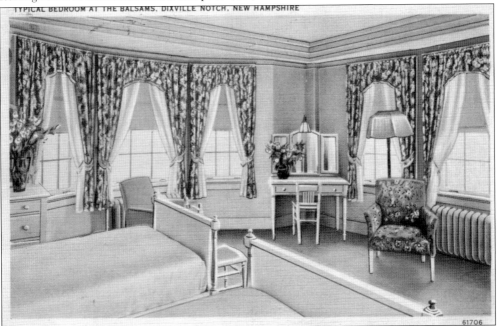

Most of the guestrooms did not change much over the years from the design seen on this 1918 postcard, except perhaps for the addition of private baths. In the late 1890s, the rooms had no baths, just a bowl, a pitcher, and a chamber pot. The rooms were sunny and cheerful, in the style of a summer cottage. (NB.)

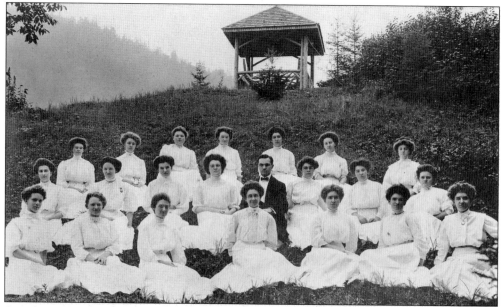

One day, a guest brought a copy of this 1912 photograph, which included her grandmother, into managing partner Steve Barba's office. She was touched and amazed to learn that Barba knew her relative's name and details about her, and that he already had the photograph in his possession. Barba was an ardent collector of Balsams history. He also received the Master of New England Inn Keeping Award. (BGR.)

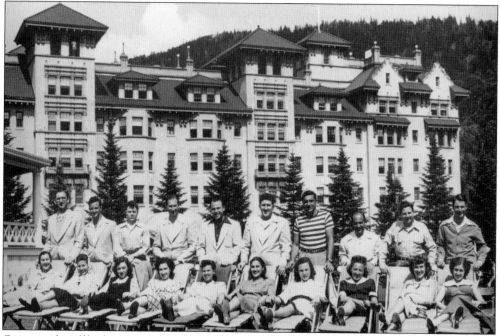

Guests and staff had a special connection. Seen here are all the honeymooners in-house one day in the summer of 1946. One couple returned as guests for many years, and the groom standing second from the right eventually became a member of the staff, handling booking for summer and winter entertainment for the hotel for several decades. (BGR.)

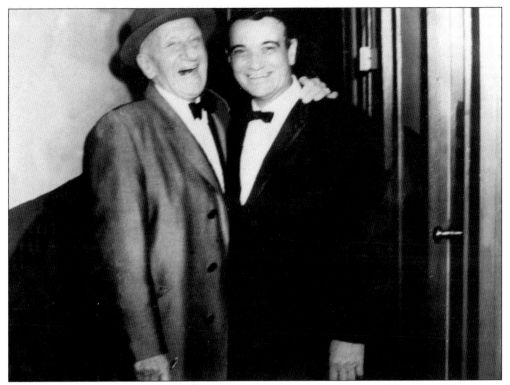

Balsams bandleader Harry DeAngelis directed all of the nightclub entertainment at the Balsams from 1959 to 1977. At season's end, he would return to Boston. He was the bandleader at the Bradford Roof and then at Caesar's Monticello, where he is seen above on the left, backstage with his friend Jimmy Durante. (BGR.)

Actor Ernest Borgnine, seen here, was a frequent visitor at the Balsams. This photograph was taken by editor and journalist Charles J. Jordan at the Lancaster Fair in 1994. Other famous people guests included Pres. Warren Harding, humorist Will Rogers, and waltz king Johann Strauss II. Before fame found him, comedian Jerry Lewis worked as a Balsams dining room waiter. (CJJ.)

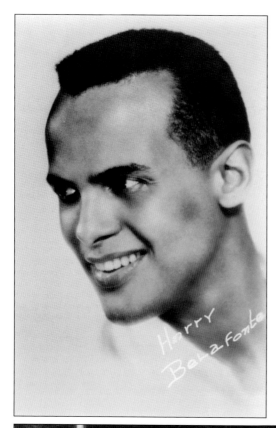

This signed photograph of singer and actor Harry Belafonte had a place of honor in a hallway known as the Walk of Fame, where photographs of many celebrities who had visited the Balsams hung. The hallway, on the second floor of the Dix House, was included in guest tours of the grand hotel. (BGR.)

The 1916 team photograph below of the Boston Red Sox features Babe Ruth (first row, fourth from left), the team's young star pitcher. In 1916, Joseph Lannin sold the Red Sox to Harry Frazee and bought the Balsams two years later with the proceeds. In 1918, Babe Ruth was famously traded to the New York Yankees. Ruth later came to the Balsams as a guest. (BGR.)

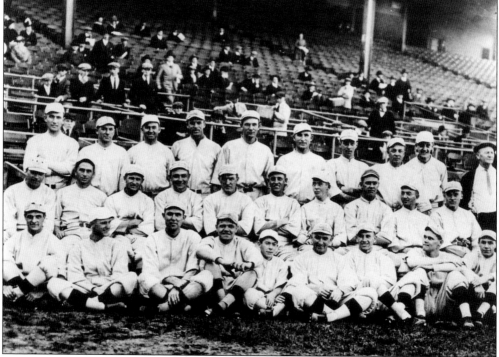

When he returned from Vietnam in 1966, Warren Pearson of Buckfield, Maine, began working at the newly opened Balsams Wilderness Ski Resort, later becoming ski director. Later, as a Balsams managing partner, he shared an office with Steve Barba for more than 30 years. Barba had started as a caddy in 1959. Pearson was the first to receive the Master of New England Inn Keeping Award, which he was awarded posthumously. (TF.)

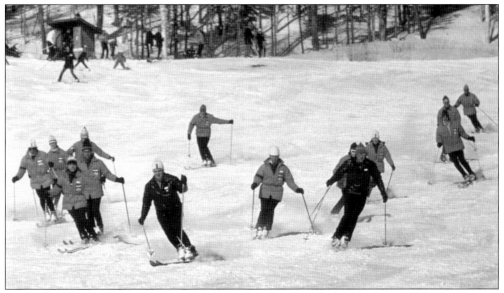

The Wilderness Ski Resort had a crack team of ski instructors, led by ski director Warren Pearson, seen here in the forefront on the left, and assistant ski director Bobby Buck, in the forefront on the right. Spread out behind them is their team, which in the early years included, in no particular order, Paula Cagguilla, Barbara Veraness, Smitty Hughes, Janie Hughes, Dean Webb, Barbie Reed, Sylvie Jolin, Fred Cowan, and Cowan's four children, among others. (TF.)

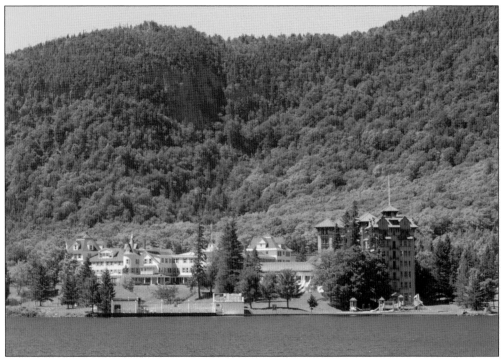

Neil Tillotson died in 2001. In 2004, the Tillotson Trust ended the Balsams Corporation lease and passed management to Delaware North. With Warren Pearson's death in 2001, and the subsequent retirements of Phil Learned and Raoul Jolin, the Balsams Corporation partnership dissolved, and the hotel closed in September 2011. The hotel was purchased in December 2011 by partners Daniel Dagesse and Daniel Hebert, who have planned a major renovation. (SZ.)

In May 2012, more than 2,000 people attended two days of auctions at the Balsams, which were held in preparation for the renovation. The new owners retained the ballot room contents and many of the hotel's historic antiques. They also formed a team of longtime employees with a deep knowledge of its history who helped choose items for preservation, particularly those with the triple-fir Balsams logo. (CHS.)

Three

DIXVILLE'S TYCOON PHILANTHROPIST

The 1900 United States census listed Neil Tillotson as "male child without a name." That nameless child went on to invent the modern latex balloon and latex examination glove. He created an international empire, along the way saving the Balsams Grand Hotel. Tillotson, along with his wife, Louise, donated millions to the community from which he had sprung. He died in 2001 at the age of 102. (TF.)

Neil Tillotson was born on December 16, 1898, delivered by his paternal grandmother at her Hereford, Quebec, farmhouse. He and his family resided in Beecher Falls, Vermont. Tillotson is seen here in the second row, fifth from the left, in this Canaan, Vermont, elementary school photograph. He is wearing the Little Lord Fauntleroy-style suit his mother insisted he wear, which led to a fight in the schoolyard defending his young manhood. (TF.)

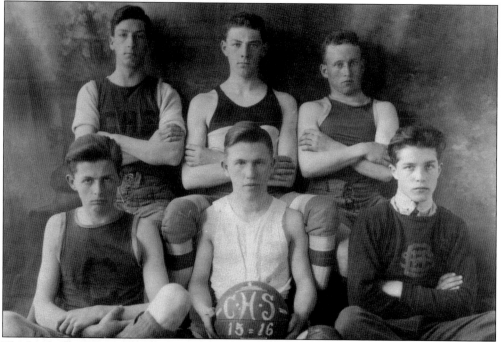

The first basketball team at Canaan (Vermont) High School was formed in 1915 by Neil Tillotson (first row, center), who became the manager. The team practiced in the upper room of Red Man's Hall, a fraternity club in Beecher Falls. Games against Colebrook involved a train ride and an overnight stay. Slated to graduate in 1918, Tillotson had to drop out in 1916, when his parents divorced and moved away. (TF.)

Neil Tillotson (above and right) joined the US 7th Cavalry in 1917 after watching Gen. Black Jack Pershing's motorized cavalry demonstration on Boston Common. Rather than a tank or motorcycle, he was issued a very large horse at basic training in Fort Worth, Texas. He spent his entire service chasing Pancho Villa on the Mexican border, never catching up with him. He was discharged in 1919, with $20 for a suit. (TF.)

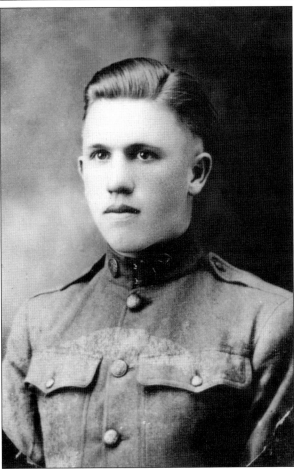

During his service, Tillotson advanced to corporal and headed a Gatling gun crew. As the war ended, his commander lined up the unit, turned his back, and asked for volunteers for Gen. John Pershing's expedition to fight the Russian Red Army. Turning around, he saw one line and thought they had all stepped forward, when, in fact, none of them had. (TF.)

CATALOG NO. 26 PB

At age 16, Neil Tillotson enrolled in a bookkeeping course at Lowell Technical College in Massachusetts, supporting himself working at a chicken farm and soda fountain. He got a job with Hood Rubber Company, cleaning its laboratory. After his Army discharge, Tillotson returned to Hood, having advanced to researcher. In 1931, he worked on developing an inner tire using latex. While that failed, it led to his invention of the first modern latex balloon. (TF.)

Hood had no further interest in latex, but Tillotson did. Through experimentation, he and his father-in-law, Mr. Gardiner, created a novelty balloon using latex, cardboard, and string. He convinced the Deciccio Company to purchase 15 gross (144 balloons per gross) at $2.50 apiece by April 19, Patriots' Day. Tillotson, his brother Harry, and Mr. Gardiner worked around the clock and produced 13 gross by the deadline. (TF.)

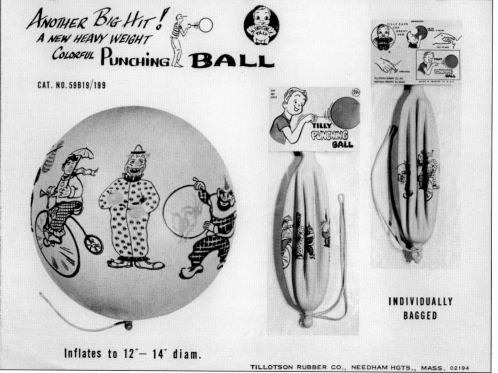

ANOTHER BIG HIT!
A NEW HEAVY WEIGHT
COLORFUL PUNCHING BALL

CAT. NO. 59B19/199

Inflates to 12"—14" diam.

INDIVIDUALLY BAGGED

TILLOTSON RUBBER CO., NEEDHAM HGTS., MASS. 02194

Neil Tillotson attended the Lexington Patriots' Day Parade and observed a child with his balloon, painted as a cat with whiskers, a cute nose, and pointed ears. Her mother called her, and as she ran off, she pulled the balloon down and planted a kiss on its kitten nose. That was enough market analysis for Tillotson—he sealed an exclusive deal with Deciccio's. One year later, he had sold $84,000 worth of balloons. (TF.)

In this 1940s photograph, John Tillotson, Neil Tillotson's oldest son, stands with his father at the home office in Wellesley, Massachusetts. Neil Tillotson was also the father of Janet and Neila by his first wife, Dorothy, and Tom and Rick by his second wife, Alma. Tillotson often said that the secret to success was in "not knowing enough to know you couldn't do something." (TF.)

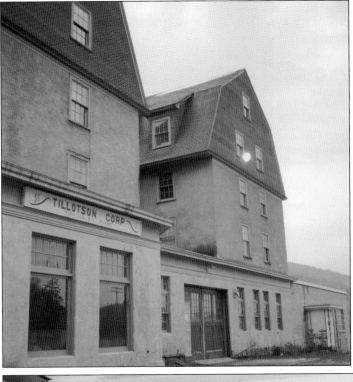

In the 1950s, Neil Tillotson began moving a portion of his Needham, Massachusetts, operation to Dixville. A crew with a good work ethic was needed, and he found it in the North Country. His sons Tom and Rick later headed the Tillotson Rubber Company, and it was a success story for many years, employing 650 people in the 1990s. Unfortunately, the factory laid off most of its employees in 2003 and closed in 2010. (TF.)

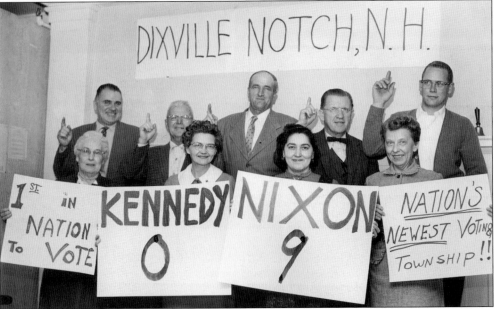

In 1960, Dixville was granted the authority to conduct its own elections. It opened its polls at midnight, closing them at 12:01. With only nine voters, it was a swift process. Thus began a tradition of Dixville being the first in the nation to vote in presidential primaries and in the presidential election. Included in this celebratory photograph of the 1960 election are Neil Tillotson (second row, second from right), who is flanked by Frank Nash to the left and Raoul Jolin to the right. (TF.)

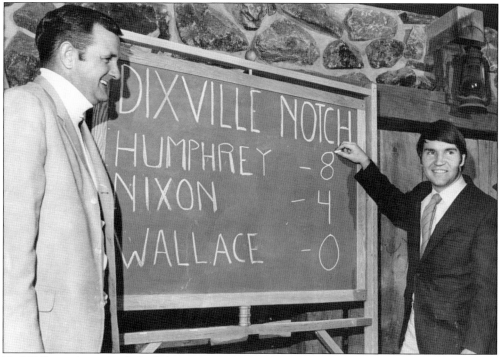

Neil Tillotson's son Rick (right) writes up the local results of the 1968 election, when Hubert Humphrey received eight votes, Richard Nixon received four votes, and George Wallace received zero. In 2008, Barack Obama became the first Democrat to win Dixville's vote in a presidential election since 1968, winning by a 15-6 margin. (TF.)

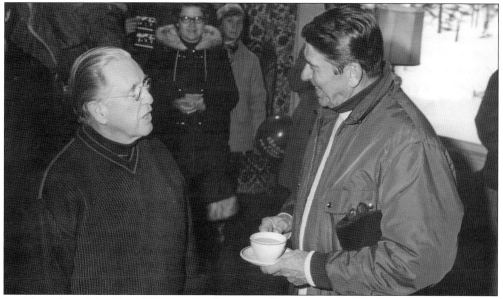

Presidential candidate Ronald Reagan made a trip to the Balsams in his 1976 run for the Republican nomination. Here, he and Balsams owner Neil Tillotson, who was also the town moderator, spent a few minutes chatting in the John Dix Room. Many candidates found their way to the Balsams, including father-and-son presidents George H.W. Bush and George W. Bush. (NS.)

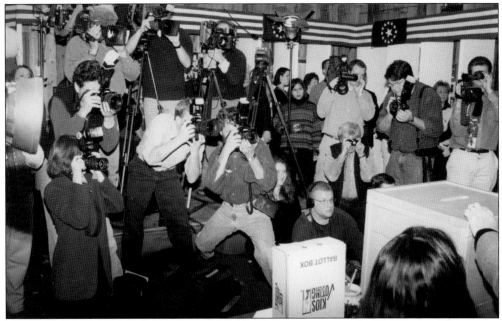

Neil Tillotson was the first man to cast his vote in every national election for 40 years. He cast his last "first vote" at the age of 101 in the 2000 presidential election. A throng of international press jammed into the tiny Balsams Ballot Room to record the moment, including the author of this book, in the first row on the far left. The Dixville "First in the Nation" continues today. (CJJ.)

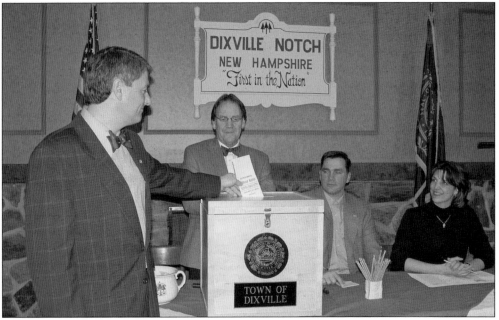

In 2004, at the "First in the Nation" presidential primary since Neil Tillotson's death, Rick Erwin (far left), was the first voter. He wore a bow tie in Tillotson's honor. Tillotson's son Tom (second from left) served as moderator and acting town clerk. Phil Learned's son Steve (second from right) was the assistant supervisor of the checklist; and Sharon Pearson (far right), Warren Pearson's daughter-in-law, was the supervisor of the checklist. (NS.)

Four

COLEBROOK

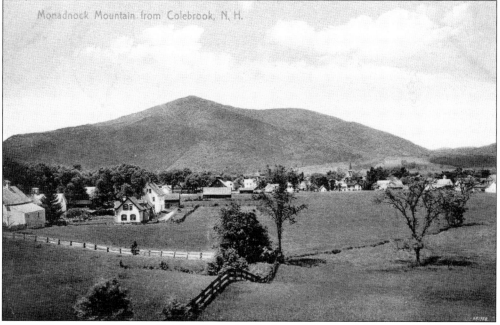

This 1909 photograph shows Colebrook, in the shadow of Vermont's Mount Monadnock, with the Connecticut River, hidden among the trees, as its western boundary. It was originally granted to Gov. Benning Wentworth in 1762, and named Dryden. With no settlers, however, the grant was forfeited. On December 1, 1770, Colebrooke-Towne was granted to Sir George Colebrooke by King George III. (NB.)

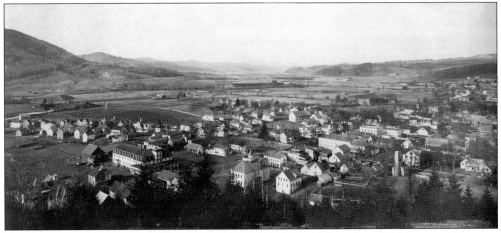

The three original roads in Colebrook were River Road (now Main Street); what is now Pleasant Street, leading to the Mohawk River and points east; and a third going up Titus Hill into Columbia. By 1800, the population was 160. The 2010 US Census recorded 2,301. This aerial photograph shows Monadnock House on Main Street, in the left foreground, and the Colebrook Grammar School, flanked by Titus Hill, in the center foreground. (CHS.)

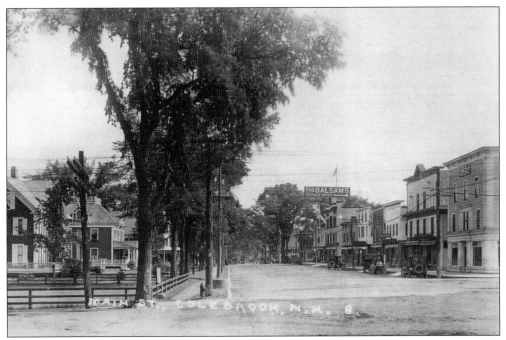

This photograph looks north on Main Street (now Route 3) at the junction of Route 26. A large sign points visitors to the area's major attraction, the Balsams Grand Resort in Dixville, 11 miles east. On the left corner, where the Big Apple convenience store is today, was a town skating rink. On the right was the Farmers and Traders National Bank, which is now Citizens Bank. (NB.)

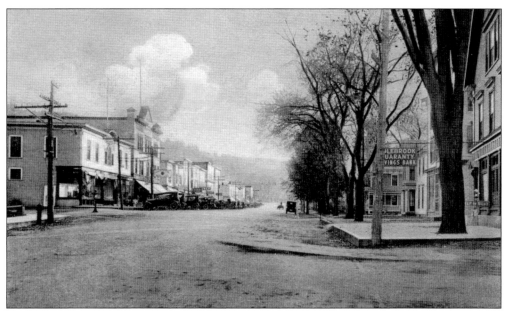

The building on the left corner of this south-facing view of Main Street was once Pratt and Smith and is now Hicks Hardware. Owners David and Cindy Hicks expanded into what had once included Vancore's Jewelers, the Colebrook post office, and Ellingwood's clothing store. The business has been in the Hicks family for several generations. Northern Outlet, Hill's Department Store, Ducret's Sporting Goods, and Northern Tire are also multigenerational Main Street businesses. (NB.)

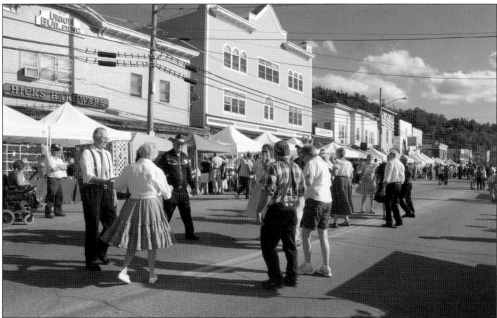

Recently, Hicks Hardware owners David and Cindy Hicks removed siding to restore the original second- and third-floor facades, as seen in this street scene at the 20th-annual North Country Moose Festival. The festival is held on the last weekend in August each year in the towns of Colebrook, Stewartstown, Columbia, and Errol, and in Canaan, Vermont. (SZ.)

The Colebrook National and Guaranty Savings Bank, built in 1888, was opposite Hicks Hardware on Main and Bridge Streets. The building became First Colebrook Bank, which moved to a new building in 1966, adjacent to the Colebrook Public Library. The former bank building is now Le Rendez-Vous Café and Bakery, opened in 2000 by Verlaine Daëron and Marc Ounis, who are both from France. (SZ.)

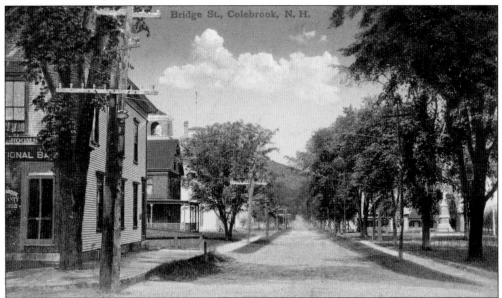

Founded in 1876, the *Weekly News* consolidated with the *Northern Sentinel* in 1884 to form the *News and Sentinel*, the longest-running business in Colebrook. Located since 1961 next to Monument Park (right) on Bridge Street, it is in the third generation of Harrigan family ownership. The other local newspaper is the *Colebrook Chronicle*, founded in 2000 and published in Clarksville. (NB.)

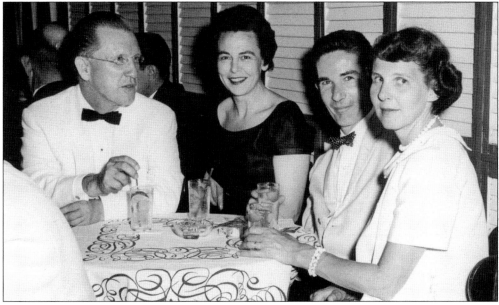

Seen here from left to right are Neil and Louise Tillotson and Fred and Esther Harrigan. The Harrigans and their partner Merle Wright purchased the *News and Sentinel* in 1960. Esther and Fred operated the newspaper until their deaths, in 1990 and 1991, respectively. A Lisbon railroad man's son, Fred Harrigan graduated from Harvard Law School and became an attorney and a judge. At the time of Esther's death, her column "The Stewpot" was the longest-running women's column in New Hampshire. (TF.)

Iva Drew was a dynamic community leader who headed a fund drive for a public library, which resulted in the Colebrook Public Library being built in the 1920s. Among her other achievements, she was a prolific poet. In 1914, Drew served as the editor of the *News and Sentinel*. As an Old Home Week committee member, she wrote the 24 scenes and 11 episodes for the event's 1935 pageant chronicling Colebrook history. (EG.)

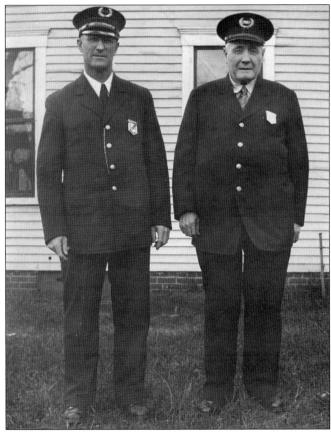

The jail (above, center) was adjacent to the Odd Fellows hall (above, left) on Bridge Street. The jail was later converted into a smokehouse, which was torn down in 1977. The Odd Fellows hall was used as a courthouse starting in 1868. The Community Baptist Church and School began services in the former courthouse in 1975. (CHS.)

Harold Carbee (left) and his father, Frank, both served as chief of police at the same time in the 1940s, in their respective towns of Colebrook and Lancaster. Harold, simply called "the town cop," was the only police officer in Colebrook at the time. He was more apt to bring miscreants home for a meal and a night's stay than to put them in jail. (SZ.)

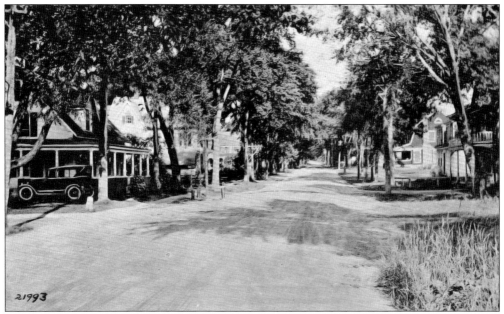

This view of Pleasant Street shows an abundance of elm trees, which once lined every street in town. In the 1930s, Dutch elm disease spread throughout the country, decimating the area's elm trees, and very few remain today. The south side of Pleasant Street is now the location of Daniel Hebert, Inc. Hebert is one of the new owners of the Balsams. (NB.)

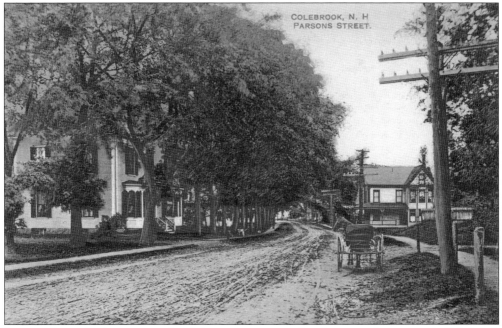

Parsons Street leading east to the Balsams is now mainly a business district, with Colebrook Plumbing and Heating, the post office, Moose Muck Coffee House, and Mostly Muffins on the north side, and Colebrook House of Pizza, Tri-Community CAP, Crooked Chimney Stove Shop, St. Stephen's Episcopal Church, Colebrook Carpet Center, and All About Kids Learning Center on the south side. (NB.)

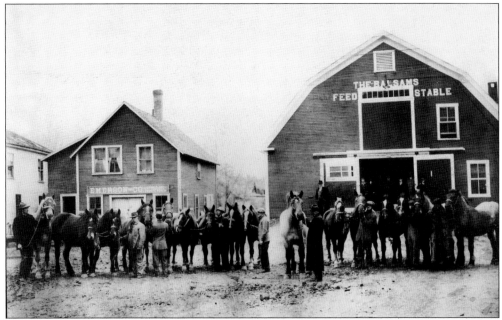

The Balsams Grand Resort built a barn to stable their horses after the extensive Main Street fire of 1901. The horses were needed for the carriages that carried their guests from the Colebrook train station to the resort. After the advent of the automobile, the stable was no longer needed. The Colebrook Grange took over the building and built a dance floor on the second story. (CHS.)

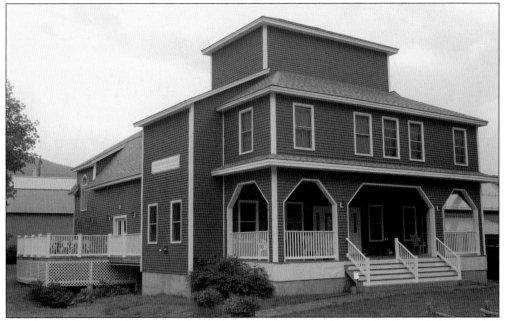

The Colebrook Grange later merged with the Mohawk Grange, leaving the former Balsams stable vacant. Paul Nugent sold it to the Colebrook Downtown Development Association (CDDA) in 2006. Grants and donations made possible the construction of the Tillotson Center there, which is now the venue for many concerts, theatrical productions, and arts programs. Events are arranged by the Great North Woods Committee for the Arts and other organizations. (SZ.)

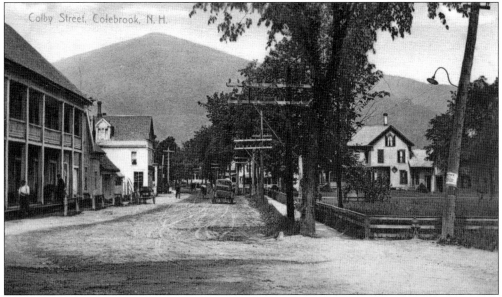

Mount Monadnock looms over Colby Street in this west-facing view. This street leads to Depot Street and what used to be the Colebrook railroad station. A bandstand once stood on the right in the field, where a rink attracted ice-skaters in winter. Colby Store was on the left, where Rite Aid is now. (NB.)

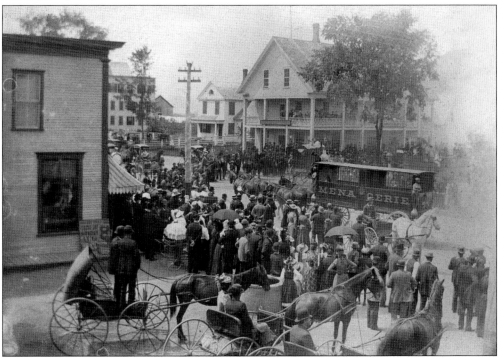

Local photographer J.D. Annis likely took this photograph of the Irwin Brothers Circus on August 8, 1892, looking from what is now Citizens Bank (formerly Farmers and Traders Bank) toward the current location of Rite Aid. Acrobats, contortionists, and a menagerie of exotic animals paraded through town to build up excitement for the show to come. (NB.)

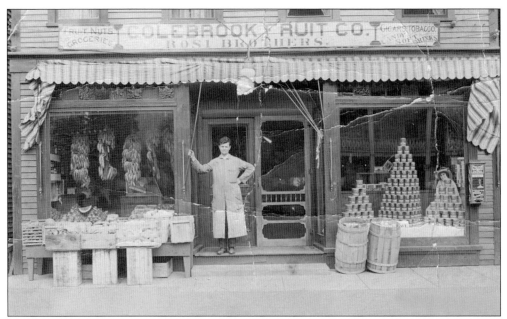

In 1910, Giovanni (John) and Giuseppe (Joseph) Rosi, natives of Gropparello, Italy, opened the Colebrook Fruit Company where Jaime's Boutique is now. Interestingly, Gropparello is on the 45th parallel, as is Colebrook. John, seen here in 1912, ran the store, and Joseph ran the fruit wagon. John married Maria Gallinari, a native of Groppavisdomo, a village neighboring John's hometown, in 1912. (TR.)

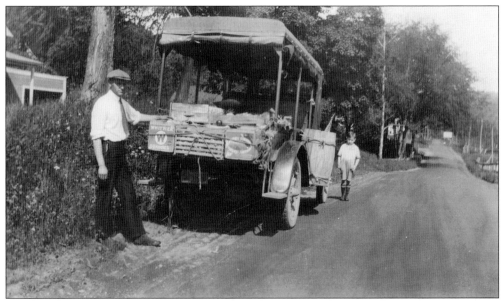

Joseph Rosi, who was called "Joe Fruit," ran the fruit wagon, traveling as far as Errol and Pittsburg. The original horse-drawn wagon was upgraded to this red motorized version. One of John Rosi's sons, Frank, is seen here with his uncle Joseph. The photograph, probably from 1925, was likely taken on South Main Street. Frank took over the store when his father died in 1939, and it closed upon Frank's death in 1976. (TR.)

This postcard features a glorified version of the Colebrook Fruit Company's horse-drawn fruit wagon, which brought a taste of Italy to northern New Hampshire. Joe Rosi got out of the fruit business in the 1920s and started a pool hall and bowling alley in the old Stevens block, where the Wilderness Lounge is now. The *News and Sentinel* offices were in that block until the 1961 fire. (TR.)

The Texaco station, seen below on the left past the Gulf station, was a hangout for old-timers and once had a restaurant. Nelson Oil Corporation built it over the former skating rink. It was operated by Otis Woodard and others. In 1957, Fred King and Bernard Ells tore down the station and built a new one, which they sold to Clifton "Stubby" Buddle in 1965. It is now C.N. Brown's Big Apple store and gas station. (NB.)

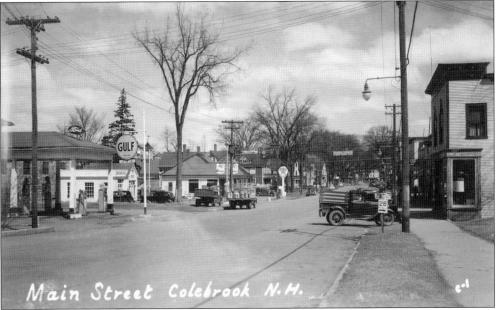

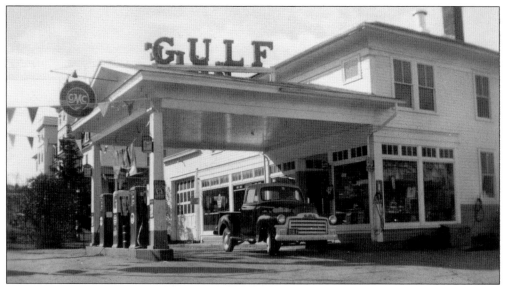

This garage was built by Harry Marsh in 1934. It had several owners, the last of which was Russell Woodard, who purchased it with Palmer Lewis in 1969. Ernest Lavigne had leased the garage from Charles J. Lewis in 1950, and purchased it in 1955. The building was eventually torn down, along with other buildings on the corner of Colby and Main Streets, to make way for the Rite Aid. (SC.)

French-Canadian immigrants and their descendants make up a significant portion of the region's population. From early settlement years onward, their hardworking, entrepreneurial spirit has helped boost and maintain the local economy. Ernest Lavigne, a Montreal woodsman, moved to Colebrook in 1946. He purchased the Lewis Gulf garage in 1955, adding a GMC dealership. His wife, Roseanne, ran a boardinghouse. All three of their children proved successful in their fields. (SC.)

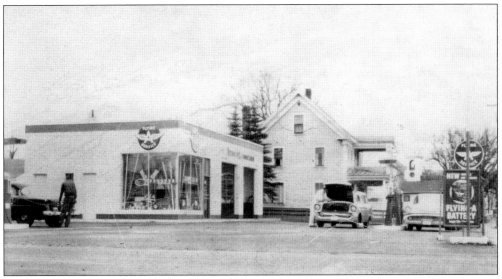

A residential building was torn down to make room for the Flying A station, owned by Tidewater Oil Company, a J.P. Getty property. It opened in 1957, with Robert Larssen (far left) having the first lease until 1959, when Victor Stanton became the proprietor of the filling station. The property then passed into the hands of Peter and Gail Nugent. (SZ.)

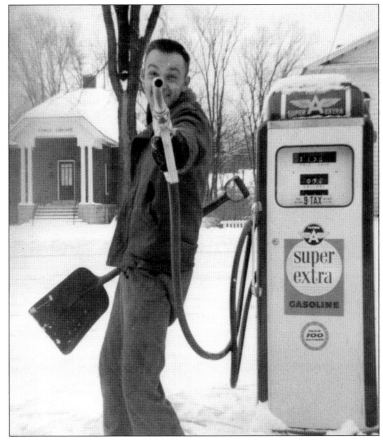

Robert Larssen clowns around on this snowy winter day in 1959. It was a difficult time for gas station owners, with a recession going on and an economy that did not yet have winter sports like snowmobiling to boost business. At times, Larssen was paid in livestock rather than cash. This station, on the corner of Main and Bridge Streets, is now vacant. (SZ.)

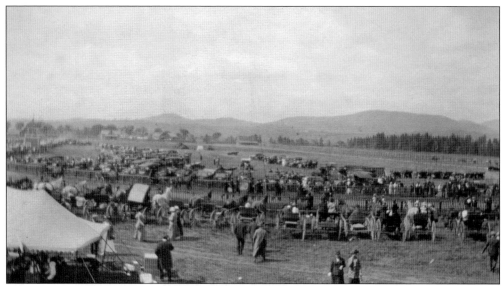

The Colebrook fairgrounds hosted a variety of events, including an annual fair. Horse races were also held in the late 1800s, with a top purse of $200. Admission for the races was 50¢, and children were 25¢. The fairgrounds overlooked the town of Colebrook from the current site of the Upper Connecticut Valley Hospital. (CHS.)

The Upper Connecticut Valley Hospital Association was formed in 1965. A grant was obtained, which provided 80 percent of the $1.4-million cost of building a regional hospital on the old fairgrounds. The 30-bed structure was built in 1970, with the Marjorie A. Parsons Wing added in 1983. Improvements continue to be made as needed. (SZ.)

Dr. Herbert Gifford and Dr. Marjorie Parsons, a husband-and-wife physician team, often found themselves the only doctors in the area. Dr. Parsons' ancestors were among Colebrook's early settlers, including George Parsons, who built the Dix House. Between the two of them, they delivered thousands of babies over the years. They also played a major role in the construction of the Upper Connecticut Valley Hospital. (CHS.)

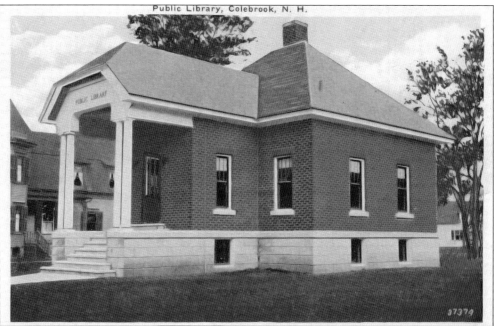

In 1808, the Monadnock Social Library was formed. After being housed in several places, including Colebrook Academy, the library was finally given its own home in 1927. The Women's Club, headed by Ida Drew, began raising money for the building in 1921, and the Colebrook Public Library was built in 1927. Masons Russell Ingram and Robert Shaw donated $500,000 for an addition built in 1988 that also housed the Masonic hall. (NB.)

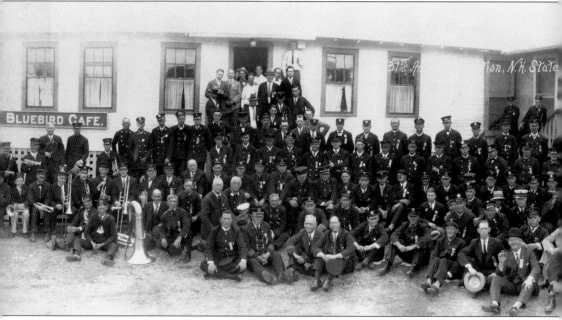

The Colebrook Fire Department hosted the New Hampshire State Fire Association Convention five times. The 1928 convention, seen here, was held at the Bluebird Pavilion in Lemington, Vermont, across the river from Colebrook. Colebrook fireman Leonard Vancore is seventh from left in the second row. Colebrook fire chief Archie Wiswell is kneeling on the far right in front, with George Smith next to him. Before a department was created in Colebrook, fire wardens

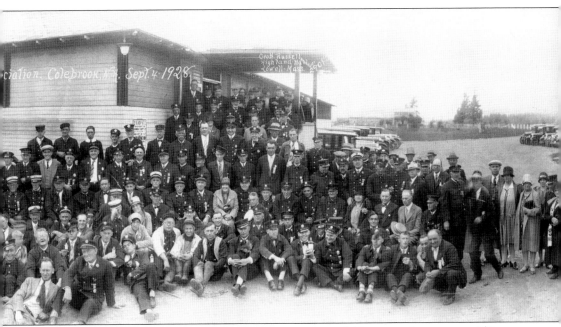

formed Mohawk Fire Company No. 1, which was not to exceed 40 men, with payment of $5 per year for their services. In 1880, the Colebrook Village Fire Precinct was formed, and a station was built in 1881 on Parsons Street. The Colebrook Fire Department was created in 1904. The company's 1881 Mohawk hand tub and 1800s chemical and soda tank can are displayed at the Tillotson Center. (CFD.)

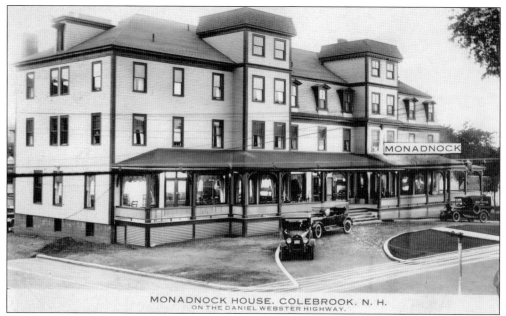

MONADNOCK HOUSE. COLEBROOK, N. H.
ON THE DANIEL WEBSTER HIGHWAY.

The original Monadnock House, constructed in the 1860s, was rebuilt after the 1895 fire. It was known for its elegant bill of fare. Harry K. Thaw turned the nation's spotlight on the hotel in 1913, when he stayed there while fighting extradition to New York for the murder of Stanford White. Pres. Warren Harding addressed a large crowd from the porch in the 1920s. The building was torn down in 1977. (NB.)

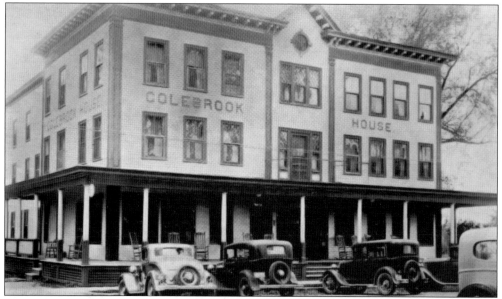

The Colebrook House began in 1830 as the Monadnock House. After it closed as the Monadnock House, it reopened, but its original name had been taken by another hotel (above), so it was renamed the Mohawk House, followed by the Colebrook House. In 2012, Roland Proulx and Rick Nadig purchased the property, began renovating, and opened the RiverEdge Inn and Dancing Bear Pub. Diagonally across the street is Howard's Restaurant, which dates from 1858 and is owned by Crystal Ball. (NB.)

Samuel and Angie Weeks (above) ran Weeks Tavern after purchasing the building in 1930. They sold it to Orrie and Doris Crawford in 1946, who renamed it the Crawford Inn. The Nugent family then converted it into a filling station and apartments. The front portion is now the home of Creative Natives. The building at one time also served as a stagecoach stop, as Colebrook's first hospital, and as a post office. (CHS.)

The Weeks Tavern now houses Creative Natives, a gift shop with a fine array of handmade crafts, art, and antiques. It is owned by Gail Nugent, who uses the old fireplace where Sam and Angie Weeks were accustomed to sitting as a focal point. The two-headed calf that was once prominently displayed in the window when it was a filling station has been retired. (SZ.)

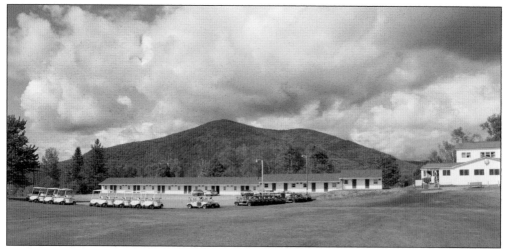

Around 1923, John Annis bought land to create the Colebrook Country Club. With the help of local shareholders, a nine-hole course was set up and the barn on the site was turned into a clubhouse. Ethan Allen Corporation bought it in 1945, and it went through multiple owners, including Norman Cote, each of whom made improvements. The 18-hole golf resort is now owned by Cote's daughter Michelle and her husband, Clay Hinds. (SZ.)

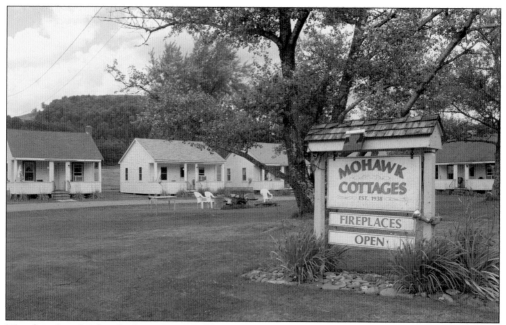

The first four Mohawk Cottages, first known as the Marshall Cottages, were built in 1938 by Herbert and Ada Marshall. Winston McCarty bought them in 1956, and then sold them two years later to Bernadine and Vic Stanton, who named them the Mohawk Cottages. Bernadine was the cottages' gracious host for 30 years. Pete and Jaye Keddy are the present owners. The main building was constructed before 1869. (SZ.)

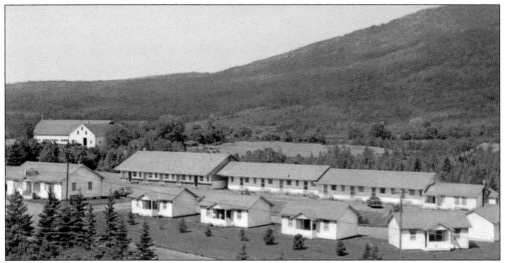

Treffle and Florence Hebert built cabins in 1950 and then constructed the Northern Comfort Motel in 1956. The Heberts' daughter, Isabelle, and her husband, Paul Brunault, took over in 1962. In 1975, the cabins were sold off, but Isabelle and her son John continued to operate the motel until it was purchased by John Kenny in 1985. Kenny's son John and his wife, Lisa, have owned the motel since 1992. Boston Red Sox legend Ted Williams stayed there in 1984. (NB.)

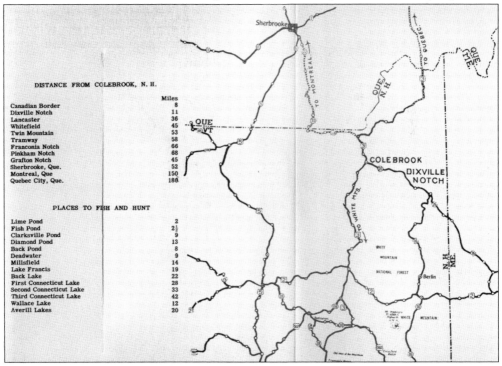

DISTANCE FROM COLEBROOK, N.H.

	Miles
Canadian Border	8
Dixville Notch	11
Lancaster	36
Whitefield	45
Twin Mountain	53
Tramway	58
Franconia Notch	66
Pinkham Notch	68
Grafton Notch	45
Sherbrooke, Que.	52
Montreal, Que.	150
Quebec City, Que.	180

PLACES TO FISH AND HUNT

Lime Pond	2
Fish Pond	2½
Clarksville Pond	9
Diamond Pond	13
Back Pond	8
Deadwater	9
Millsfield	14
Lake Francis	19
Back Lake	22
First Connecticut Lake	28
Second Connecticut Lake	33
Third Connecticut Lake	42
Wallace Lake	12
Averill Lakes	20

This 1917 map shows that the Colebrook area was and continues to be ideal for outdoor recreational visitors. Reasonable lodging in Colebrook has sprung up over the years to accommodate visitors, including the Mohawk Campground, Diamond Peaks Motel and Country Store, the Notch View Inn and Campground, the Monadnock Bed and Breakfast, and the Keazer Farm Bed and Breakfast. (CHS.)

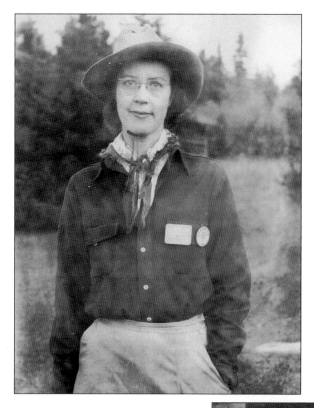

At age 20, Alice Converse became the first female guide in the state, receiving her license from the New Hampshire Fish and Game Department in 1931. A native of Pittsburg, New Hampshire, she spent the later years of her life in Colebrook. She was an outdoor guide for people from all walks of life, and even fly-casted with baseball star Ted Williams. (EG.)

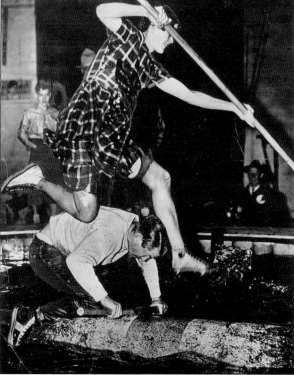

Converse and her father, Maynard, also a noted guide, competed in guide shows nationwide. They won first prize in crosscutting in their first show at Boston Garden, with a time of 4.4 seconds on an eight-foot-by-eight-foot timber. At one show, $25 was offered to anyone who could last one minute on a log with her during a logrolling competition. No one collected the prize. (EG.)

Today, tourists and area residents alike enjoy indoor water recreation at the North Country Community Recreation Center. The center opened in 2003 thanks to generous donations. It was the culmination of more than 60 years of community efforts to raise money for a pool for the area's children. It boasts an Olympic-sized pool, an outdoor skating park, and two playgrounds. (SZ.)

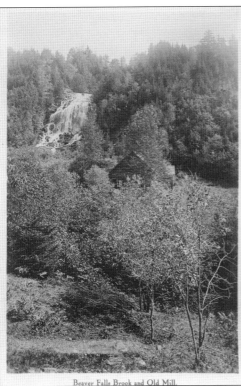

Beaver Falls Brook and Old Mill.

Beaver Brooks Falls is a scenic highlight just a short distance from town on Route 145. It became a state park in 1967. A dam and powerhouse had been built at the foot of the falls in 1890 to provide the town electricity, but the spot proved impractical. It is now a popular picnic area. (CHS.)

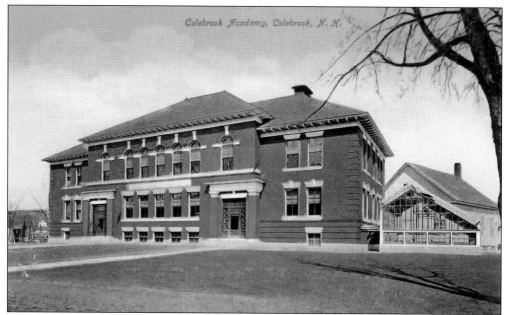

The present high school, Colebrook Academy, was built in 1911. The greenhouse (right) was torn down after ice falling from the roof kept damaging it. The first academy, built in 1852, was moved a short distance and converted into a workshop. It was torn down in 1958. A plan to make the academy a regional high school, encompassing the area from North Stratford to Pittsburg, fell through in the 1950s. (CHS.)

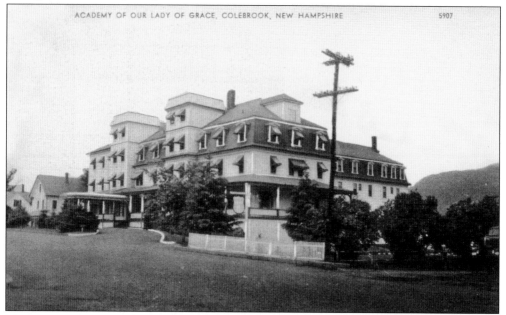

ACADEMY OF OUR LADY OF GRACE, COLEBROOK, NEW HAMPSHIRE 5907

The Monadnock House became Ethan Allen Lodge in 1944. The building was then purchased by the Daughters of the Charity of the Sacred Heart of Jesus in 1949. The order added two buildings, a grammar school and a high school—Our Lady of Grace Academy. The teachers, all nuns, lived in the former hotel. The Catholic schools closed in 1970, and the town began using them for kindergarten through eighth grade. (CHS.)

60

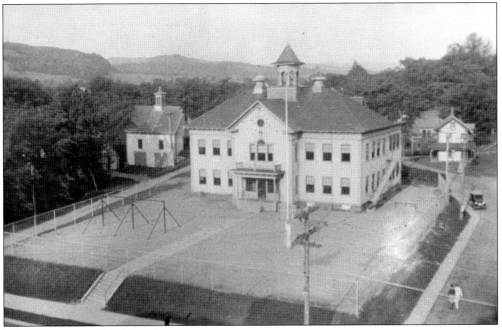

All that remains of Colebrook Grammar School (above) is an empty lot at the corner of Titus Hill Road and Main Street. The school, built in 1903 after fire destroyed the previous school, closed when the town took over the Catholic schools in the 1970s. The old grammar school remained vacant until it was destroyed by fire in 1998. (NB.)

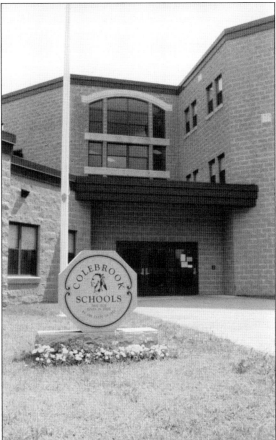

This beautiful building, with its stonework, brick, and glass features, was constructed by Daniel Hebert, Inc., in 2001. It contains classes for kindergarten through eighth grade. The granite sign was donated in 2003 by the class of 1955. Before this construction, the elementary school and the junior high school were in two separate buildings. The elementary school was razed, and the junior high building became part of the new structure. (SZ.)

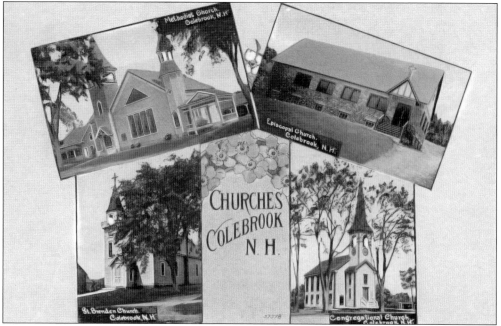

The four oldest churches in Colebrook are, clockwise from bottom left: St. Brendan's Church, on Pleasant Street since 1955 but built on Cooper Hill in 1891; the Trinity Methodist Church, 1870; St. Stephen's Episcopal Church, 1914; and the Monadnock Congregational Church, 1831. The Church of Jesus Christ of Latter-day Saints established a branch housed in the Methodist Church in 2008. (CHS.)

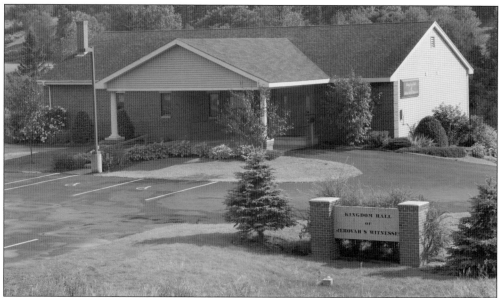

Jehovah's Witnesses have been active in this area since 1935. A Kingdom Hall was built in Colebrook in the 1960s, and another was built in 1973. On June 16, 1985, more than 600 volunteers from all over New England began construction on a 5,600-square-foot Kingdom Hall on Route 26. At 7:00 a.m., the external walls went up. Just 35 hours later, it was completed. In 2003, the hall was renovated by volunteers. (SZ.)

Five

COLUMBIA

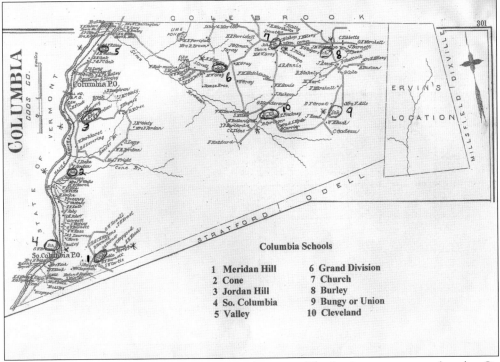

Columbia Schools

1 Meridan Hill	6 Grand Division
2 Cone	7 Church
3 Jordan Hill	8 Burley
4 So. Columbia	9 Bungy or Union
5 Valley	10 Cleveland

Columbia was chartered in 1762 and first named Preston. The land grant was transferred to Sir James Cockburne in 1770 and renamed Cockburne. In 1811, the town became Columbia. First settled in 1772, Columbia had 798 residents by 1860, slightly more than the 2010 population of 757. This 1892 map pinpoints 10 schools and two post offices, one at the north end of River Road (Route 3) and one to the south. (NB.)

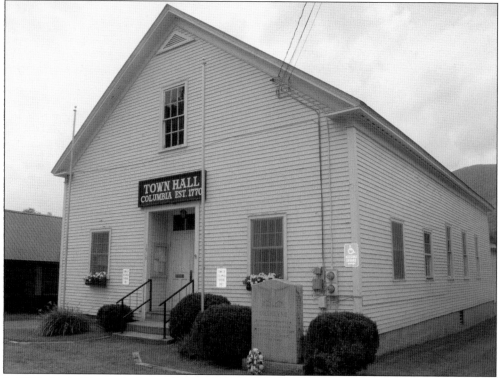

In 1900, this building, which cost $1,500, replaced the town hall built in the early 1840s. It stands at the north end of Columbia, in what was once known as the Valley, which had sawmills, gristmills, and starch mills. To the south was Tinkerville, which once boasted a hotel, a post office, a doctor's office, a store, a school, a blacksmith shop, mills, a grange, and a railroad station. (SZ.)

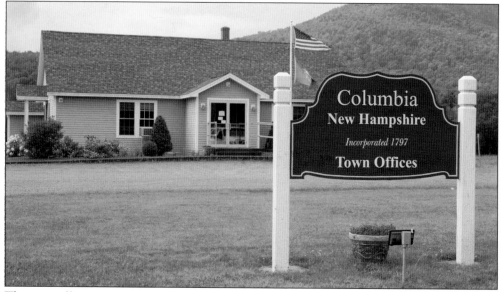

The town offices were moved from the old town hall into a new town office building constructed in 2006, on the former Winston Banfill property. The town completed payment on the $318,000 loan in just three years. The old town hall is still the site of the annual town meeting. (SZ.)

The first postmasters were E.H. Mahurin and Samuel Thomas in 1827. Rural free mail delivery began in 1905, with Don Stevens, seen here in 1909, as the first carrier. He carried the mail by sleigh and wagon for 23 years before switching to an automobile. He retired in the late 1930s. (CHS.)

This photograph from the late 1800s shows a tinker who may be a man known as Lull the peddler, peddling his wares on Meriden Hill. In 1892, with 12 families living on Meriden Hill, a tinker could do a brisk business. Tinkerville began at the foot of Meriden Hill with the former Lyman farm, now known as the CJEJ farm. (NB.)

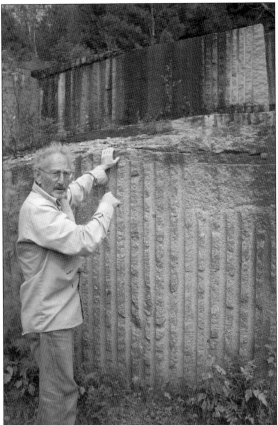

Silas Curtis, a farmer and stonecutter on Meriden Hill's upper end in the 1860s, hand-cut pink granite found on his property. The Rock of Ages Company mined here from the 1970s through the 1990s, calling the stone Columbia Pink. The Smithsonian Institute in Washington, DC, and the rebuilt Pentagon building both contain Columbia Pink. Retired schoolteacher Bill Schomberg, who once worked at the quarry, is seen here pointing out the drill marks. (SZ.)

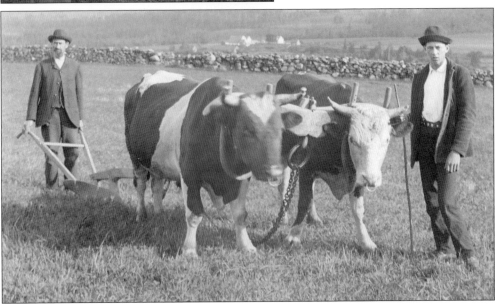

Charles Titus is one of these men preparing to plow with a team of oxen in a field on Titus Hill. Oxen proved useful for a variety of purposes around 1900. They were the heavyweights on the farm and elsewhere, and were often used to pull logs out of the woods in the wintertime. (CHC.)

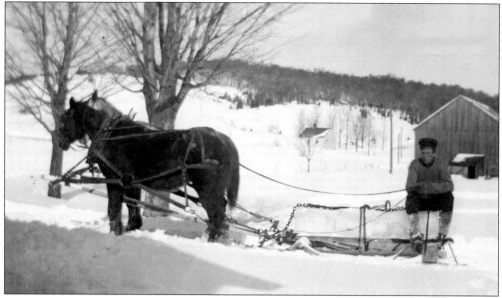

A Meriden Hill resident rests from his labor of cutting ice for the family's icebox and milk house. Before the advent of the electric refrigerator in the early 1900s, farmers harvested ice from area lakes and ponds. Ice harvesting is still practiced at the Remick farm in Tamworth, New Hampshire. (CHC.)

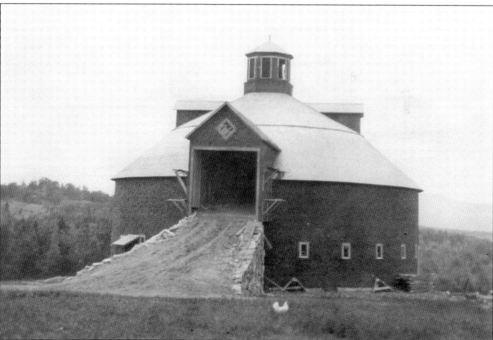

James Kelsea built this round barn on his farm in East Columbia in 1922. It was torn down in the 1980s. Parts of East Columbia are called the Bungy. Some think the term means to "bruise and batter," or "where the four winds come together." Both are good descriptions of this locale's fierce winds. A severe storm in the area was often referred to as a Bungy Blizzard or a Bungy Bull. (CHC.)

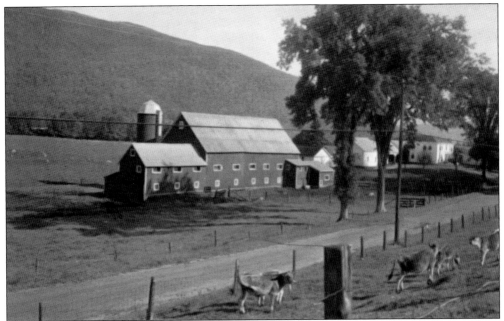

William Wallis, born in 1741, purchased the lot where the Pioneer Farm is located today on Route 3. In 1785, Wallis's sons cleared the land and built a cabin. The farm has passed through six succeeding generations. The last descendant, Lew Wallace Jr., left the farm to his widow, Ruby, who, along with Robert Young, restored much of the farm. It is listed in the National Register of Historic Places. (NB.)

Maple syrup production is still part of the Pioneer Farm's operation. Spring means tapping the trees and an old-fashioned "sugaring off." Sap is boiled to the soft ball stage and poured on snow, making what is known as "sugar on snow." Doughnuts and coffee are usually offered on sugar house tours, and the finished product is for sale. Chappell Products is another Columbia maple syrup operation. (PR.)

Chester Jordan, seen here, the grandson of the first settlers on Jordan Hill, was New Hampshire's 57th governor, elected in 1900. He had been the principal and superintendent of schools for Colebrook. Addison Hobart, born in Columbia in 1819, was the father of Garret Hobart, who was elected as the 24th vice president of the United States in 1896. Hobart died in office in 1899, and was replaced on the Republican ticket by Theodore Roosevelt. (ML.)

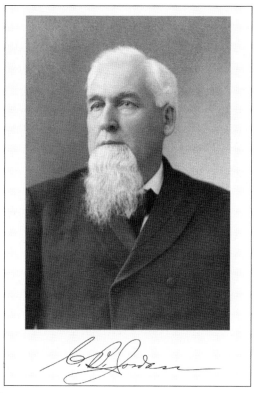

Elmer Annis, born in 1861, sits with his daughters Lena and Mertie. Elmer was the third generation of his family to live in East Columbia. He married Abbie Weston of Hereford, Quebec. Elmer's granddaughter, Mabel Sims of Columbia, was instrumental in the creation of the book *History of Columbia, New Hampshire*, which is dedicated to her. (NB.)

The war ration book belonging to Mertie Annis Oakes has been passed down through generations. It reflects the experiences that shaped her generation, which survived the Great Depression and raised families during the deprivations of World War II, when basic commodities such as butter, sugar, and gasoline were restricted. (NB.)

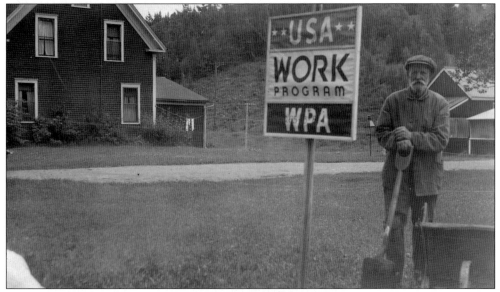

Newton Moser, a hired hand for Columbia Lodge and Cabins, stands by a USA Work Program sign. The Works Progress Administration (WPA) was formed in 1935 and dissolved in 1943. It was an ambitious New Deal project headed by Harry Hopkins of Pres. Franklin Roosevelt's administration. It provided millions of jobs for the unemployed during the Great Depression. (NB.)

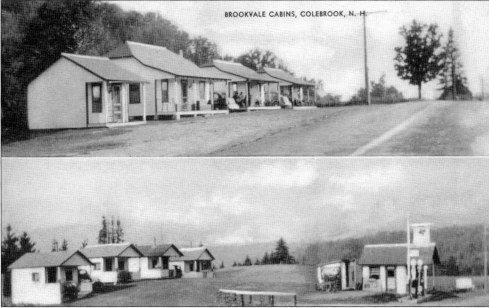

BROOKVALE CABINS, COLEBROOK, N. H.

Florence Pilbro purchased property in 1916 from Hazen and Maude Curtis. She founded the Brookdale Cabins (above), a lodging business and small store along Route 3. The cabins have been on the site since at least 1928. She sold her business to her son Ernest and his wife, Gladys, in 1961. It operated as the Pilbro Cabins until the 1970s. (NB.)

A photographer captured the serenity of spirit of a youthful Florence Pilbro before her marriage to Truman Pilbro. Florence operated the Pilbro Cabins while running a small dairy farm at the same time, beginning her day milking the cows. She was respected as one of the hardest workers in her community. (NB.)

Born in 1904, Columbia resident Mabel Sims, the daughter of Lovell and Mertie Oakes, ran a boat rental from 1960 to 1996 on Fish Pond. She bought her cabin lot from Colebrook clothing store owner Charlie Hill in the late 1950s. Opening day of fishing season at the Sims cabin was a big event for area fishermen. Sims died in 1997. (NB.)

Jeannette Holbrook ran the lodge and cabins below in the 1930s and 1940s. She sold the cabins to Charles and Bernice McLaughlin in 1945, and they were renamed the Columbia Cabins. The property passed through several hands, including Francis Colburn and G. Laurence Gettings, Aura Hodge, and James and Lorraine Santacroce. The cabins are now closed. (NB.)

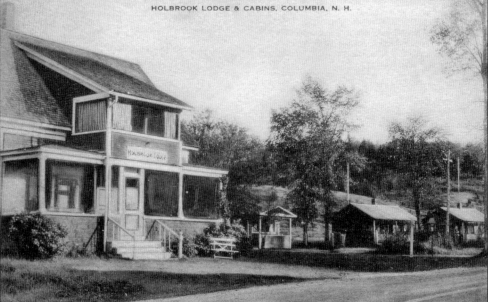

HOLBROOK LODGE & CABINS, COLUMBIA, N. H.

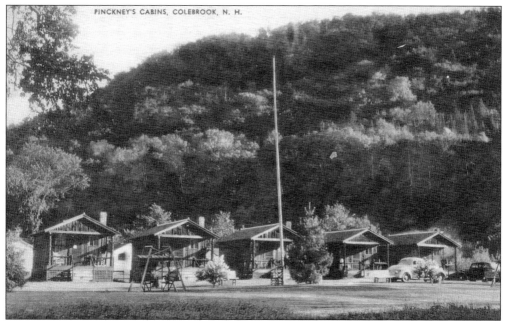

Pinckney's Cabins, now known as Rippling Brook Cabins, were built in 1929 by Charles Pinckney and Thomas Pinckney Jr. after the bobbin mill burned down in 1926. The cabins sit alongside Sims Stream. Charles Pinckney's daughter-in-law Berneice Carbee Pinckney helped run the cabins and a small restaurant across the street while raising a large family. The cabins have had multiple owners through the years. (NB.)

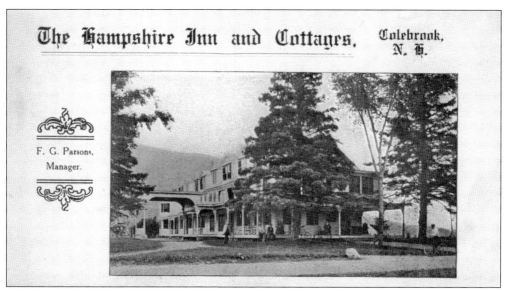

The Hampshire Inn and Cottages. Colebrook, N. H.

F. G. Parsons, Manager.

In the late 1800s, French Canadians were coming into the region in growing numbers. In 1921, the Oblate Fathers established a community to minister to this population. The order bought the old Hampshire Inn, built in 1892 by Clara Parsons, the widow of Dix House owner George Parsons. St. Joseph's Seminary opened in Columbia in 1922. The Juniorate moved in 1943, and the building then housed a Novitiate. (NB.)

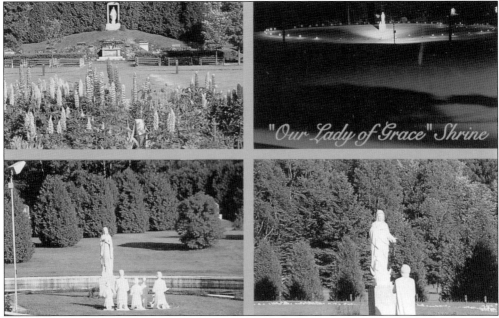

To commemorate the 25th anniversary of the Oblates' founding in Columbia, the local Oblates decided to erect an eight-foot statue of Our Lady of Grace in white Carrara marble. Over the years, the shrine has expanded to include 15 acres, a small lake, a Rock of Ages granite altar, and numerous statues. The Leon LaPerle family was the model for the family worshipping at the Lady of Lourdes. (NB.)

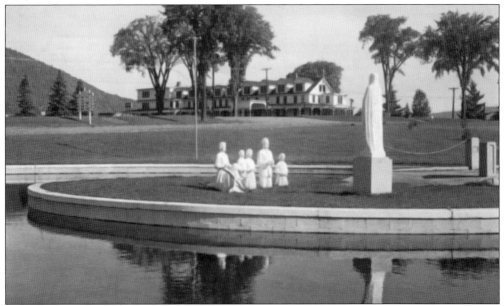

The LaPerle family, model for the statues in the foreground, was headed by Leon LaPerle, born in 1915 in Pittsburg, and his wife, Adrienne, of Paquetteville, Quebec. They purchased the Red and White grocery on Colby Street in Colebrook in 1956, opening an IGA store there. Their son, Guy, the boy statue at the shrine, constructed a new building on Main Street and opened IGA Plus. Guy LaPerle's son Gerry is the assistant manager. (NB.)

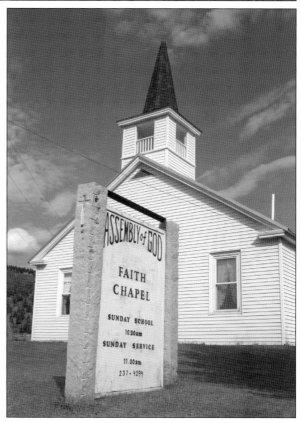

The 36th Blessings of the Motorcycles at Our Lady of Grace Shrine (above) drew more than 5,000 motorcyclists in 2012. This annual event was inspired by Rev. Albert Beausoleil of the Missionary Oblates of Mary Immaculate. The first event was hosted by the White Mountain Riders in Berlin and is now hosted by the Cougars Motorcycle Association. This biker statue was added to the shrine in honor of family motorcycling. (SZ.)

The First Assembly of God Church began services at the town hall in Columbia in 1954. The present church was completed in 1957 on land purchased for $1 from Ellery Adair. In 1975, the name was changed to Faith Chapel Assembly of God. On September 12, 2004, the congregation celebrated 50 years in the North Country with a reception and presentations. (SZ.)

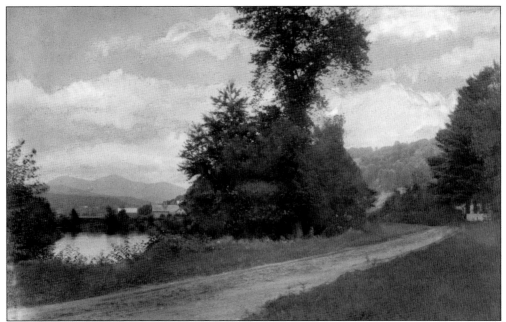

This vintage postcard looks south down the Connecticut River and into Columbia on its eastern bank. The three peaks of Goback (Bowback), Teapot, and Lightning Mountain in Stratford provide a backdrop to one of Columbia's many hills. A peaceful country road follows the Connecticut River around a bend. (NB.)

The Goback range is part of the Vickie Bunnell Preserve, which is partially in Columbia. This preserve has 13 mountains higher than 3,000 feet above sea level, including Columbia's Bunnell Mountain, the highest peak north of the White Mountain Forest. The preserve contains 28 miles of stream frontage, as well as many ponds and bogs. Columbia guide Ken Hastings of Osprey Adventures offers outdoor adventures on the area's waterways, including the Connecticut River. (SZ.)

Six

STEWARTSTOWN

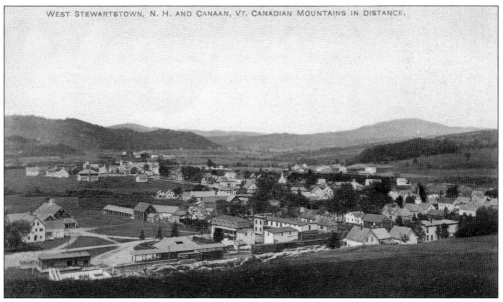

WEST STEWARTSTOWN, N. H. AND CANAAN, VT. CANADIAN MOUNTAINS IN DISTANCE.

The township of Stewartstown was granted on December 1, 1770, to Sir James Cockburne, Sir George Colebrooke, and John Stuart, Esq., all of London, and John Nelson, of Grenada. It was incorporated as Stuart in 1795, and incorporated again in 1799 as Stewartstown. A total of 13 landowners were listed on the petition for incorporation. It encompasses 46.8 square miles. The 2010 census showed a population of 1,004. (BU.)

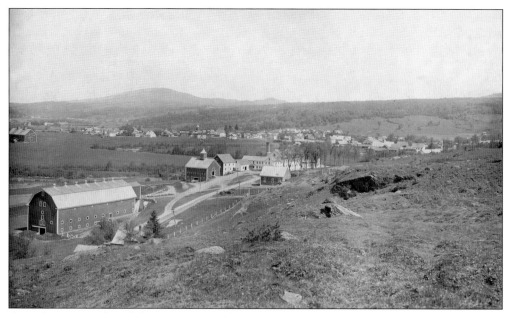

Coös County purchased the Isaiah Pickard farm, south of West Stewartstown, and opened the Coös County Almshouse for the poor in 1867. The present Coös County Jail was built in 1914. The Coös County Nursing Hospital was constructed in 1932. The county farm, which provided work for prisoners, closed in 2011. Santa's Tree Farm in Colebrook leases county fields and creates a cornfield maze every autumn. (BU.)

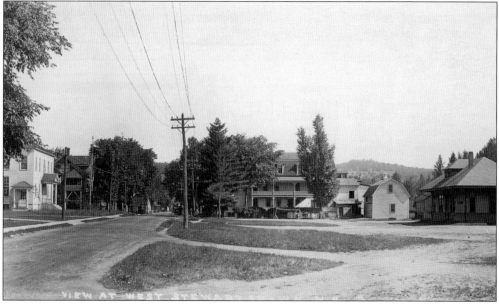

Washington Street, seen here before 1918 heading north through the village of West Stewartstown, had a railroad station (right) and an apartment complex known as the Bean Block, to the station's left. The Bean Block was destroyed by fire. The former station now houses the Marquis Trucking Garage. Marquis True Value Hardware and Towle's Mini Market, which sells model trains, now stand on the former station's south side. (BU.)

Jo Hobbs was a telephone operator who handled a switchboard from the Bean Block. The Stewartstown, Colebrook, & Connecticut Lake Telephone Company formed in 1888 and had an office in West Stewartstown. Hobbs usually knew whether the person the caller was seeking was home. If the message was urgent, she would often know where he or she was, and would go out and relay the message in person. (BU.)

The F.W. Baldwin store (below) was built in 1902 by Frank Baldwin. He handled prodigious amounts of produce from his store; in 1904, he loaded 52 carloads of locally grown potatoes at the West Stewartstown and Beecher Falls, Vermont, train stations. George Currier bought the store in 1923, and his daughter, local historian Ellie (Currier) Gooch, was born above the store in 1928. (EG.)

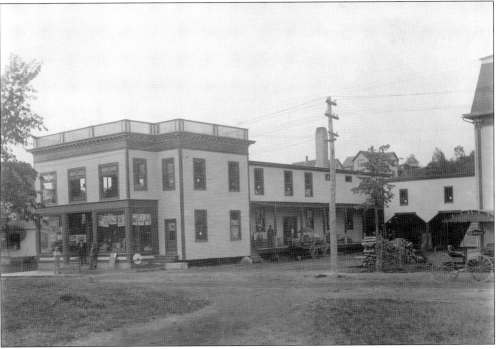

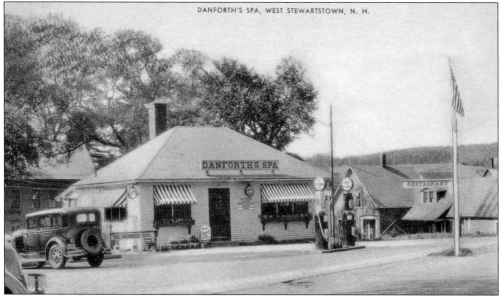

The southern corner of Washington and Main Streets once held Roy Marsh's variety store, which sold harnesses and carriages, the *Northern Gazette* office, and Leon Ripley's law office. This stretch burned in 1909. Danforth's Spa was built on this corner in 1931. Francis Grondin purchased the building in 1992, operating it as the Spa Restaurant. Grondin opened the Outback Pub beneath the restaurant in 1994. (NB.)

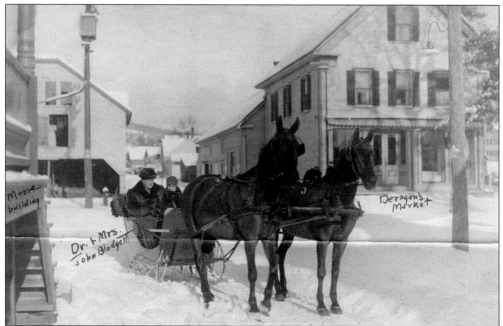

Dr. and Mrs. John Blodgett, seen here in the sleigh, lived in the Little Clipper Salon building, east of the brick building owned by Ford Moore that lodged a bakery, a restaurant, and a photography studio. The Moore building's stairs are on the left. Deragon's Market stood on the western corner of Center and Main Streets. Another salon, Joanne's Added Attractions, now adjoins Memorial Park, behind what was the Stewartstown Hotel lot. (BU.)

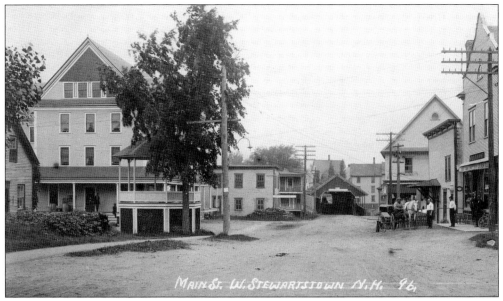

Main Street, seen here in a west-facing photograph, included the pavilion on the left, which was rebuilt in 1980. Four hotels stood beyond on what is now Memorial Park, including the Stewartstown Hotel. The last hotel burned in 1925. Jackson's Restaurant is also seen here, as well as the building that later housed the fire station. Loverin's store was on the opposite side of the bridge, with the Gem Theatre upstairs. Stub Baker's barbershop and Merrill Pharmacy were east of Loverin's. (NB.)

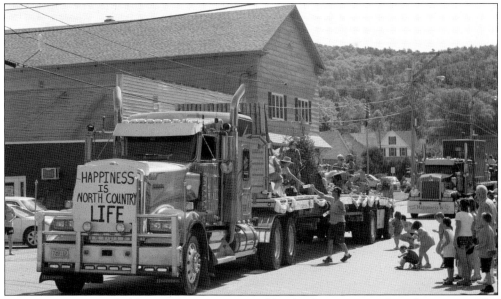

Stewartstown Day is held every August, organized by the Stewartstown Day Committee. The event includes a parade, fireworks, and a bazaar. It is held following a sugar on snow event and softball tournament in Canaan, Vermont. The 2012 float theme was "What Is Happiness?" This photograph facing east on Main Street shows Pauline's Boutique, in what was Stub Baker's Barber Shop. The former Merrill Pharmacy building now includes Sally's Beauty Shop and Daley's Wash. (SZ.)

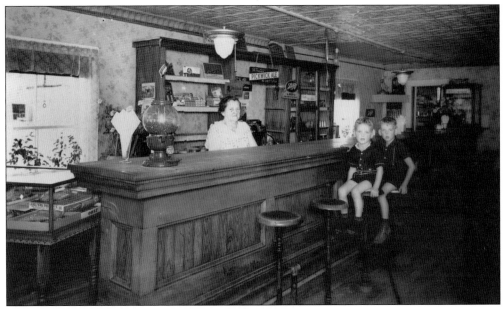

Belle Ripley ran what later became Jackson's Restaurant, operated by Carroll Jackson. Ripley's reputation as a great cook made her popular with the locals. Coming out of the woods following a long winter, lumberjacks would buy clothes at Joe's Store, have a bath, a shave, and a haircut at Stub Baker's barbershop, and then head to Belle's for a meal and a beer. Ripley is seen here behind the counter with James (left) and Ricky Wright. (GR.)

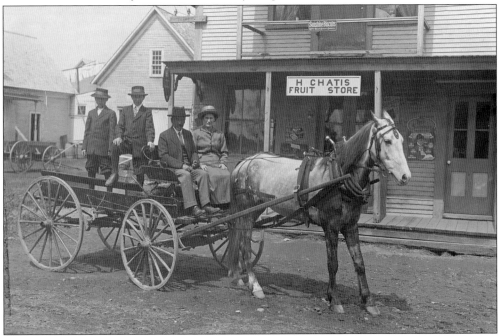

Mr. and Mrs. Hyman Chatis, with their sons Louis (left) and Israel, pause for a photograph in front of H. Chatis Fruit Store. The store was in what is now a residence, two houses west from the Route 3 intersection on Main Street's northern side. A fleet of stagecoaches that served the region's hotels in the summer were once kept behind what is now the Spa Restaurant. (BU.)

Joseph Solomon emigrated from Lebanon in 1909. He sold household goods from a backpack, traveling on foot from farm to farm. He eventually established Joe's Store in 1936 in the former Catholic church building east of Merrill Pharmacy. His daughter Pauline and her husband, Bernard Daley, took over in 1959. They built Solomon's Store on the Loverin's store site in 1969, which is now operated by their sons Michael and Bruce. (SZ.)

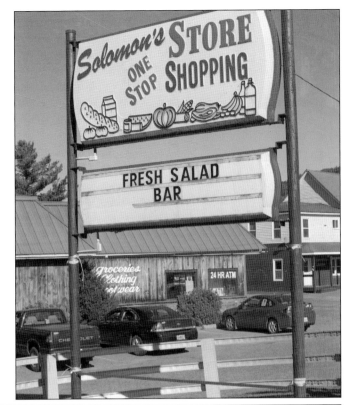

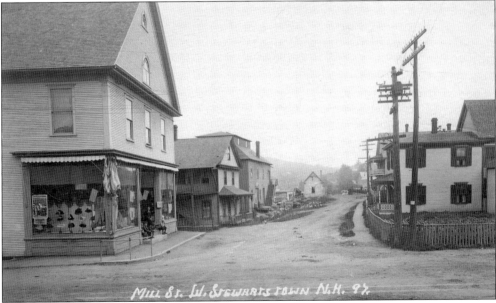

Mill Street, seen here looking north from Loverin's, had a small mill that made moldings, a gristmill, an electric plant adjacent to a dam, a railroad siding, a sawmill, two blacksmith shops, and Cook's Store, directly behind Merrill Pharmacy. Historian Emily Hayne's father, Charles Harriman, built caskets at one mill during the 1918 Spanish influenza pandemic. A 1904 map lists the W.F. Allen Saw and Planing Mill and Electric Light Plant. (BU.)

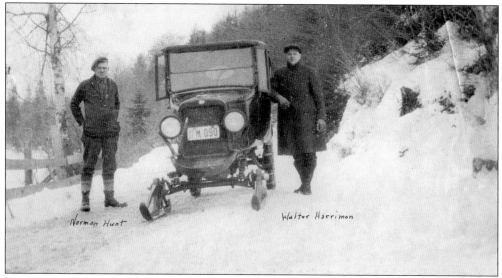

Norman Hunt

Walter Harriman

Stewartstown resident Norman Hunt (left) is seen here on the road with Walter Harriman and his Ford Model T "Snowmobile." Hunt, a Public Service of New Hampshire employee, was killed on June 11, 1930, while on the job. His wife, Dencie Ladd Hunt, died on December 17, 1930, of tuberculosis. The year before, they had lost their home in the Colebrook flood. They left behind eight children. (BU.)

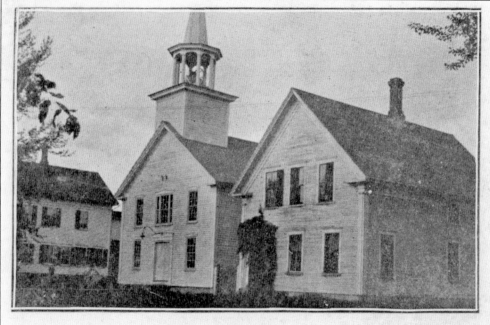

CONGREGATIONAL CHURCH & PARSONAGE, W. STEWARTSTOWN, N. H.

The First Congregational Church was organized in 1846. It was changed to the Gospel Chapel in 1948, and the congregation joined the Independent Fundamental Churches of America in 1950. The name was changed to the Independent Baptist Church in 1965. This photograph shows the Parker House (on the far left), which has been replaced by the Stewartstown Town Office. (NB.)

The Stewartstown Town Office contains the Dennis Joos Memorial Library, named in honor of the late Stewartstown resident and Colebrook *News and Sentinel* editor and his heroic actions in a tragic 1997 Colebrook shooting. Three individuals also honored posthumously for their heroism during that event were attorney and associate judge Vickie Bunnell of Columbia, state trooper Scott Phillips of Colebrook, and state trooper Leslie Lord of Pittsburg. (SZ.)

Just north of town, up the hill across from the 45th parallel sign, there was once a wooden fort, built during the War of 1812 to protect border residents. A state militia made a forced march to Pittsburg in 1835 to quell the Indian Stream Republic uprising. A company of soldiers was stationed at this fort in 1918 to guard the railroad bridge in West Stewartstown. (GR.)

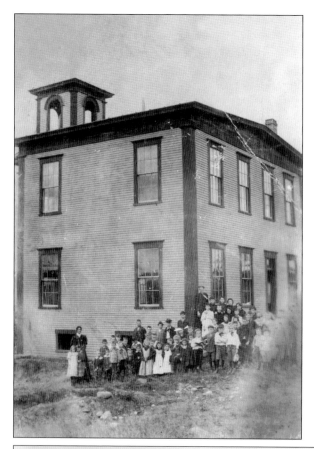

This 1895 photograph shows the school that once stood on High Street, on what was called Pension Hill, where an A-frame structure now sits. One former student, Linwood "Cy" Harriman, recalled that "the wind would blow in one side and out the other" during the severe North Country winters of his youth. (BU.)

The Stewartstown Community School (below) was built in 1998, consolidating the West Side School and the Stewartstown Hollow School. Town meetings, which had been held in the Stewartstown Hollow town hall, built in 1892, were transferred to the new school. Town meetings in the Hollow often featured a snowstorm and a political battle between the east and west sides of town, according to one longtime resident. (SZ.)

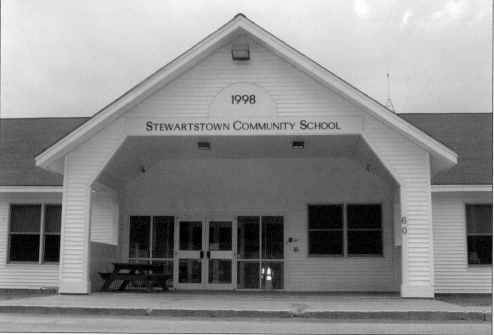

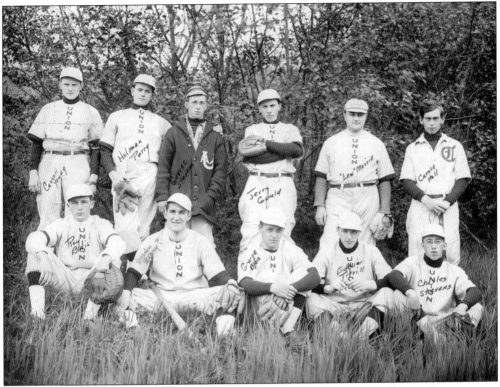

Youths from Stewartstown and Canaan, Vermont, made up the Union baseball team. Stewartstown youths in this photograph include Roy Blais (first row, far left), George Blais (first row, third from left), Carroll Young (second row, far left, who operated Young's Pharmacy, the former Merrill Pharmacy, from 1928 to 1955), and Lew Merrill (second row, fifth from left). Around 1950, Carroll Young and Joe Solomon formed an athletic team for Stewartstown boys. (BU.)

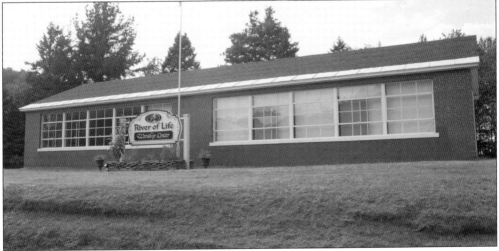

The Stewartstown Hollow School was built in 1959, and closed in 1998. Some former students have chosen to settle nearby, while others are in far-flung places. One former student lives in Australia, working as a civil engineer. The building has housed the River of Life Worship Center since 2010. (SZ.)

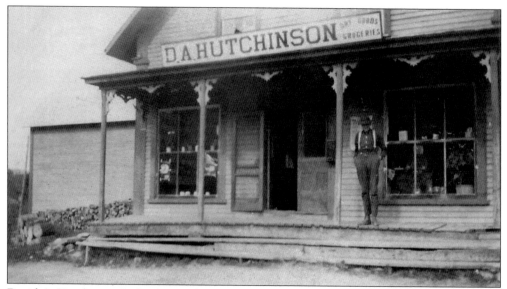

David A. Hutchinson had a dry goods and grocery store across from the old Stewartstown town hall, on the corner of Route 3 and Bear Rock Road. The building dated from about the same era as the hall, the late 1800s. Harold Carbee once ran a grocery store in this building, and lived above the store. It was also owned by the Boudle family at one time. (TF.)

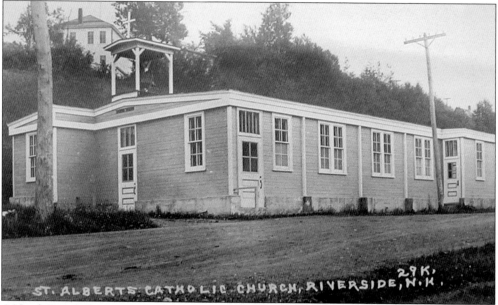

A North Stratford mission served the Stewartstown area from 1890 to 1926. The mission eventually moved to Riverside, but a chapel was built in 1921. A second floor was later added. In 1926, Rev. L.A. Ramsay was nominated as the first resident pastor of St. Albert Church, and opened a parochial school in 1927. The Sisters of the Presentation of Mary taught 127 children in the first year. (NAMP.)

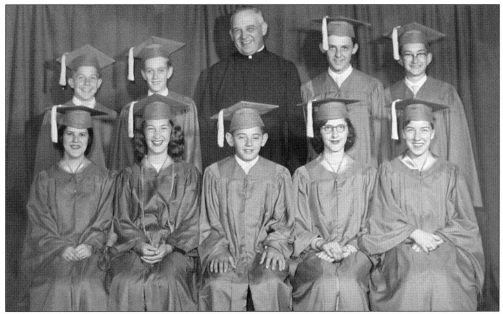

St. Albert's eighth-grade class poses for a 1958 graduation photograph in caps and gowns. The class includes, from left to right, (first row) Marguerite Richard, Marietta Robinson, Normand Fauteaux, Suzelle Riendeau, and Marie Claire Chaloux; (second row) Leo Chaloux, Maurice Thibault, Rev. Leo Nadeau, Ronald Marquis, and Leo Paradis. (NAMP.)

In 2000, the Diocese of Manchester withdrew the Sisters of the Presentation of Mary from St. Albert School. Through tuition, fundraising, and donations, the community kept the school open with lay teachers, but the diocese decided to close it in 2003. At the closing ceremony in the modern St. Albert Church, on June 15, 2003, many of the order's teachers returned for a fond reunion with students and parents. (SZ.)

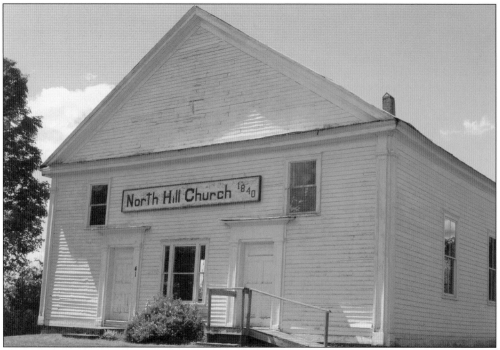

The North Hill Church was built in 1840 and is cared for by the North Hill Church Preservation Society. The church opens its doors every year in August for an ecumenical service. It still has its original boxed-in pews and kerosene lamps. North Hill Cemetery, a few miles farther along on the same road, contains the headstone of Metallak, the last chief of the Abenaki Coashaukes. (SZ.)

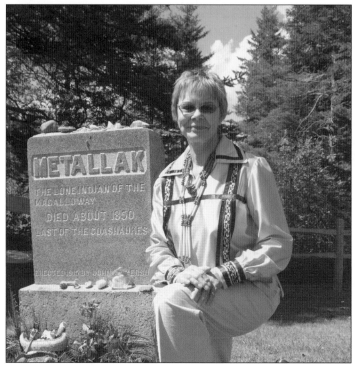

Linda Tillotson of Colebrook, Neil Tillotson's daughter-in-law, is the great-great-great granddaughter of Chief Metallak. Metallak visited Quebec's St. Francis Indians, which were largely Abenaki. They were on a reserve named Odanak, near Pierreville in Yamaska County. Tillotson's mother, Stella Metallic, was born on the Micmac Reserve in Restigouche (now Listuguj), Quebec, where Metallak's grandson Thomas settled. Chief Metallak, blind and a ward of West Stewartstown, died in 1847. (SZ.)

The Poore Farm Museum on Route 145 is open to the public in the summer. Kenneth C. Poore (1885–1983) willed his 100-acre farm to the Poore Family Foundation with the aim of educating the public about rural life before electricity changed the face of farming. The farm never had electricity. The farmhouse was built in 1826 by Moses Heath and sold to Kenneth Poore's father, Job, in 1832. (SZ.)

Little Diamond Pond is in the 1,573-acre Coleman State Park. The park was created when the State of New Hampshire bought the Horace C. Coleman estate in 1957. It is a beautiful, isolated spot, but comes alive with snowmobiles during the annual Swift Diamond Riders Snodeo in March. The pond was the site of Little Diamond Pond Camps around 1900. (NB.)

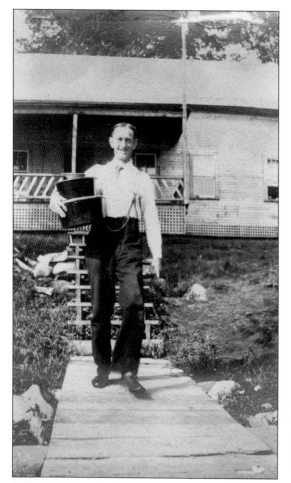

Big Diamond Pond lies below Little Diamond's north side. Big Diamond Pond Camps, a tourist lodge created in 1903, once sat on its shores but no longer exists. The pond was also where the Sportsman's Lodge welcomed visitors for many years. One of the Dannatt brothers, possibly George, who owned the camps with his brother Edward, is seen here walking along a camp walkway in the course of his day's work. (CHS.)

A Big Diamond Pond Camps guest, with her net and fishing pole in hand, prepares to embark by fishing boat for a day out on Big Diamond Pond, which was famous for its abundance of trout. In 1908, the *News and Critic* reported that Fred Vancore of Colebrook caught 16 trout totalling 22 pounds. (CHS.)

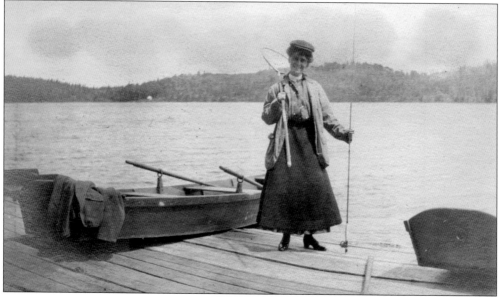

Seven

RIVERS AND RAILROADS

This poster of a Maine Central freight train hung for years in Maine Central employee Harold Carbee's Colebrook office. It shows a Santa Fe 2-10-2 steam locomotive first used in 1903. Maine Central operated from 1862 until the 1970s. At its height, it had more than 1,000 miles of tracks leading from Maine to northern New Hampshire, Vermont, and Canada. The Maine Central system evolved from more than 50 railroads. (SZ.)

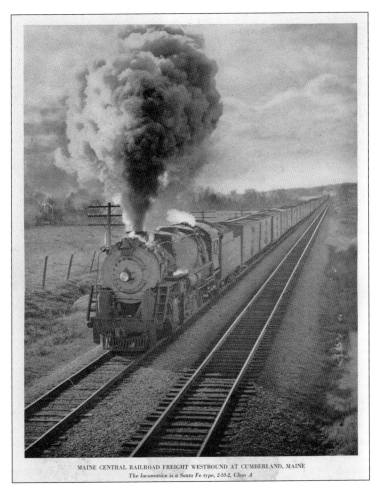

MAINE CENTRAL RAILROAD FREIGHT WESTBOUND AT CUMBERLAND, MAINE
The locomotive is a Santa Fe type, 2-10-2, Class A

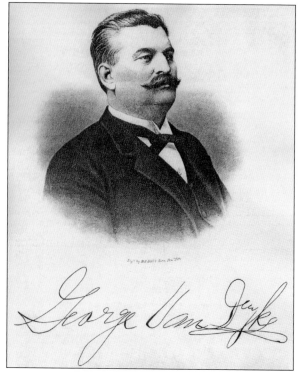

(SZ.)

Attorney John Poor of Bangor, Maine, is considered the father of Maine's railroad system. In 1845, he braved a blizzard as he raced to Montreal through rugged Dixville Notch. He beat out the Bostonians for the Atlantic & St. Lawrence Railroad charter, and his efforts ended the North Country's isolation. Poor originally sought a Dixville route for the railroad, which failed to materialize. (SZ.)

George Van Dyke, the lumber baron and founder of the Connecticut Valley Lumber Company, opened the Upper Coös Railroad in the late 1880s, with stations in Colebrook, West Stewartstown, and Beecher Falls, Vermont, among other towns. He died in 1906, when his Stanley Steamer automobile went off a cliff near Greenfield, Massachusetts, while he was watching his last big Connecticut River drive of 53 million feet of logs. (CVHS.)

George Van Dyke was the undisputed timber king in 1900. For many years, he controlled the upper Connecticut River, which flowed from its headwaters in Pittsburg, New Hampshire. This pre-1914 photograph shows Stewartstown's covered bridge, the Allen mill and dam, and the railroad bridge. In the forefront is Van Dyke's barn, which was said to have stabled 60 racehorses. (BU.)

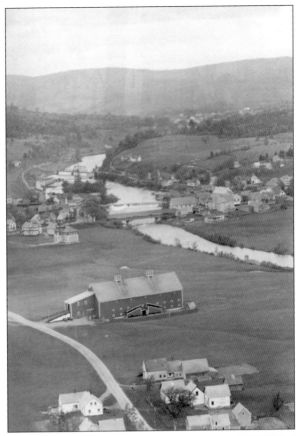

Below, Sam Keeble, a driver for lumber baron George Van Dyke, leads a team of oxen through the streets of Canaan, Vermont, just across the bridge from West Stewartstown. Drivers often used oxen or workhorses to pull logs out of the woods to the river and the railroads. It was one of several methods used by loggers to reach the market. (CVHS.)

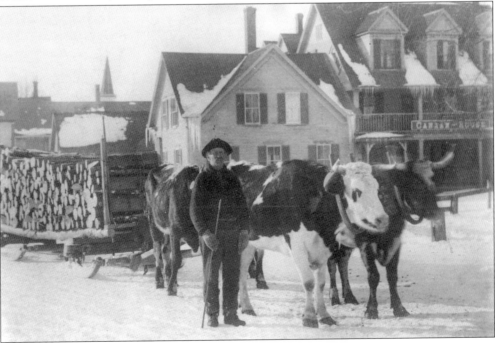

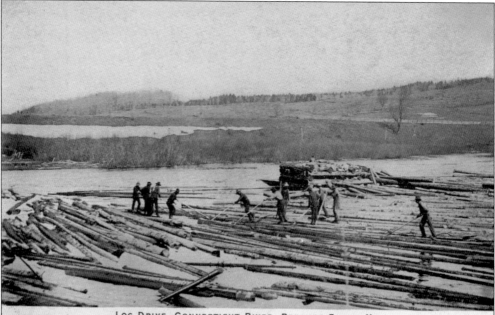

LOG DRIVE, CONNECTICUT RIVER, BEECHER FALLS, VT.
Published by B. McDonald, Beecher Falls, Vt.

In the above view of the Connecticut River into Beecher Falls from Stewartstown's banks, lumbermen use pike poles with iron hooks to direct logs. The spring "freshet" meant temperatures were causing snow and ice to melt, filling up the deep woods rivers. Spring thaw raised water to levels that allowed the logs to be driven downstream to larger waterways. The waters were often raging, and frequent injuries and loss of life were common. (NB.)

These spiked boots with inch-long steel caulks, which are on display at the Colebrook Historical Society Museum, helped keep lumberjacks' footing sure on the slippery rolling logs. The boots were a staple of a logger's outfit, and he took good care of them, keeping them greased and ready for when the ice went out and the river drives began. (SZ.)

This photograph shows a lumber camp cook and his assistant, called the "cookee." The cook was second in importance only to the foreman. If he was good, he did much to hold a camp together. Tom Brackett, who cooked at most of the Van Dyke camps, was a legend among loggers. One logger, in a 1958 interview, recalled Brackett making baked goods fit for an award at the county fair. (CHS.)

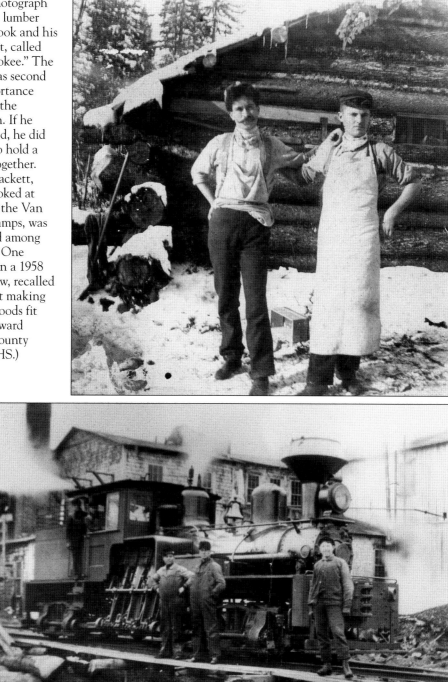

This Connecticut Valley Lumber locomotive is similar to the one hauled into Millsfield, near Dixville, for the logging railroad built by the Berlin Mill Company in 1910. The Millsfield locomotive was transported by oxen, horses, and block and tackle over Kelsey Notch. A total of 900 tons of rail were hauled, much of it through Dixville. The operation ended four years later, with the area stripped of its old-growth spruce. (CVHS.)

Mills processing logs were plentiful, like the Washburn Mill and Dam in Kidderville. It was built about 1900 by a Mr. Jordan. Abe Washburn purchased it in 1927. It was destroyed by the 1929 Colebrook flood, but Washburn rebuilt it in 1930 and operated it until 1946. His son-in-law Harold Jackson ran the mill until it closed in the 1960s. Jackson's widow, Henrietta, later took it down for safety reasons. (CHS.)

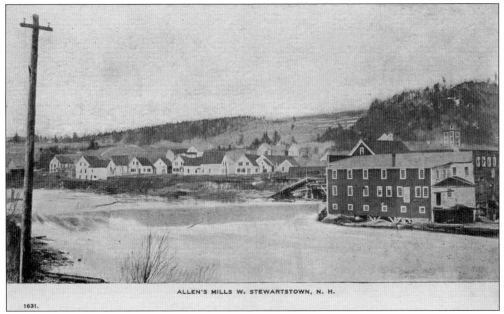

ALLEN'S MILLS W. STEWARTSTOWN, N. H.

1631.

In 1872, the Allen family bought the Eames mill. It was water-powered initially, but by 1904, the W.F. Allen Mill had become an electric plant, providing electricity for West Stewartstown, Canaan, and Beecher Falls, Vermont. It also ran lines to Colebrook. In the early 1920s, the plant was sold to Lyman Lombard, who sold the plant in 1926 to Public Service of New Hampshire. (NB.)

As early as 1898, the United States Bureau of Forestry recommended that trees be treated as crops, and forestry management took root. St. Regis Paper and International Paper, which took over from St. Regis in this area, began employing foresters. These St. Regis employees seen at the West Stewartstown office in 1951 are, from left to right, George Abel, Vermont-New Hampshire Division woodland manager Fred Cowan, Dave Lewis, John Miller, and Al Trombly. (CVHS.)

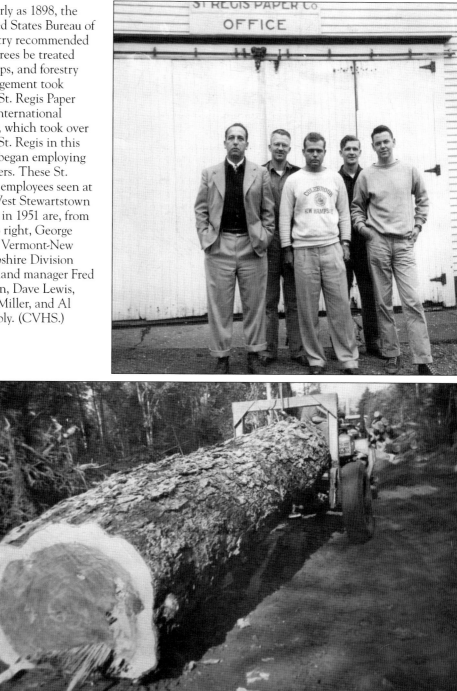

This 1950 photograph shows a log harvested by the Blair operation on St. Regis's Smith Brook land in Pittsburg. This yellow birch log produced 1,359 board feet. It broke the crane lifting it into the truck for delivery to North Troy, Vermont. The mill's conveyor entrance was enlarged for the log, but the lathe was unable to handle it, and another opening was cut to remove the giant. (FC.)

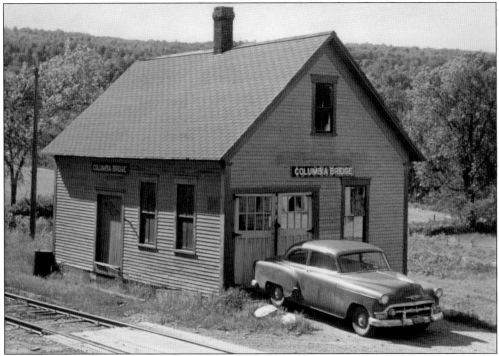

In 1890, Maine Central took over the Upper Coös Railroad and Hereford Railroad, chartered by George Van Dyke. These lines ran from North Stratford through Columbia, Colebrook, Stewartstown, and Beecher Falls (Vermont) to Hereford and Cookshire, Quebec. Columbia had a flag stop, and in the early 1900s, it housed the post office and a store. A ride from Columbia to Colebrook in the 1930s and 1940s cost 10¢. (NB.)

In the 1950s, state highway construction meant the removal of the defunct Maine Central flag stop in Columbia. Gerald Gray bought the station for $1 at auction. Jack Greer (far right), thought to be the last surviving lumberjack from the big log drives, helped move the station. The former station sits just south of the Columbia Bridge and is now Francis Gray's garage. (FG.)

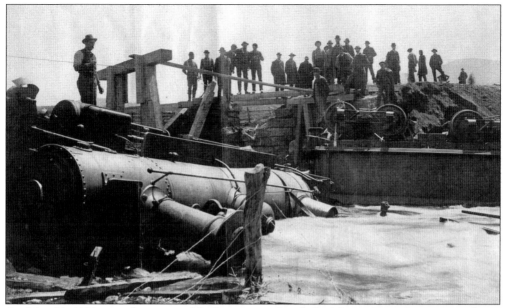

On May 21, 1890, a washout caused by heavy rain derailed a Maine Central train just after it crossed over Cone Brook. All aboard escaped injury, but the railroad superintendent, James Twohey, and a section hand, Alba Lull, were killed. They had been examining the line for washouts and were caught under the train. George Van Dyke was among these men extracting the bodies from the wreck. (CHC.)

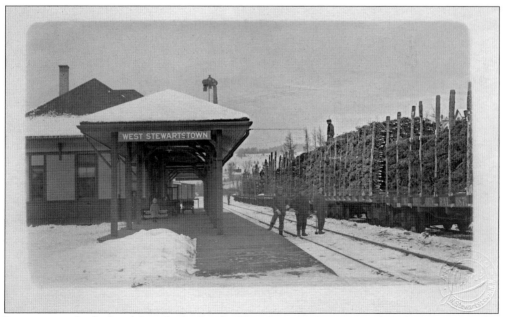

Passengers embarked and disembarked at the West Stewartstown station, but the station was also the means to transport goods in and out of the area. In winter, thousands of Christmas trees were loaded onto the cars. There are more than 200 Christmas tree farms in New Hampshire today, most of them family owned. (BU.)

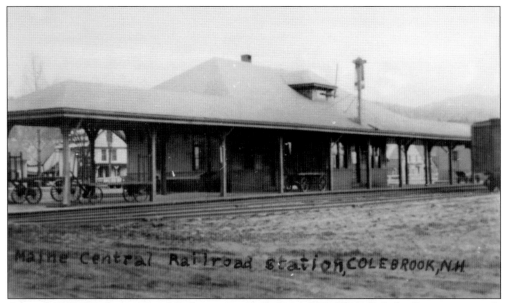

Maine Central Railroad Station, COLEBROOK, N.H.

Around 1900, between six and eight trains came through Colebrook daily. Sometimes, with the loading and unloading of livestock, it resembled the Wild West. Although the Upper Coös Railroad was already operating in 1887, a grand celebration took place in May 1888. Rockets and cannon shots heralded the train, and railroad president George Van Dyke was on the platform to greet it. The Colebrook station now houses Brooks Agway. (CHS.)

Harold Carbee of Colebrook, a 35-year Maine Central man, maintained the cars to prevent a "hot box," the overheating of axle bearings, which could cause fire or derailment. Known as a "car knocker," Carbee would walk along tapping the wheels with a hammer, telling by the sound if they needed grease. A hot box never happened under Carbee's watch. He died on the job in 1958 at age 71. (SZ.)

By the 1950s, only a solitary compartment remained to carry passengers between Columbia and Colebrook. However, Eunice "Tommie" Richards remembers the engineer on freight runs sometimes stopping at her house by the tracks in Beecher Falls, Vermont. He would give her children, Wayne and Winnie, a ride to Colebrook in the caboose. This 1950s photograph shows teenager Richard Larssen enjoying his moment in the engineer's seat. (SZ.)

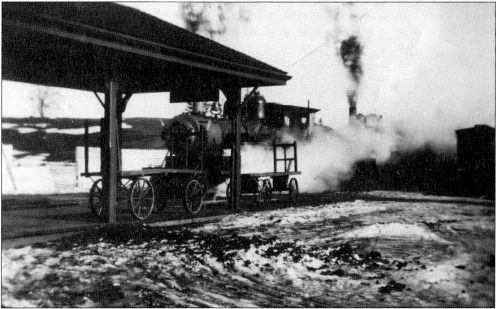

Ed Jeffery of the Central New Hampshire Railroad leases tracks from North Stratford to Colebrook, operating a railcar and engine repair facility at the southern end of the old Upper Coös Railroad line. In July 2012, the state began tearing up the 10-mile northern section for recreational use, beginning at the Bridge Street crossing in Colebrook. This New Hampshire section ends at the bridge north of West Stewartstown. (CHS.)

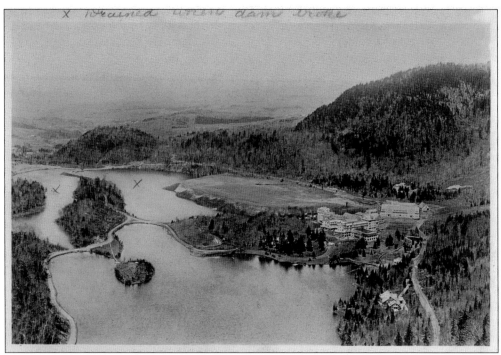

Henry Hale, who in 1895 became owner of what would become Balsams Grand Resort, added two lakes to the west of Lake Gloriette: Lake Coashauk (top right), where the lower golf course is now, and Lake Abenaki (top left). Decades after his death, these lakes were the cause of the worst flood in Colebrook history, when the dam, weakened by heavy rain and snow melt, collapsed on May 3, 1929. (CPL.)

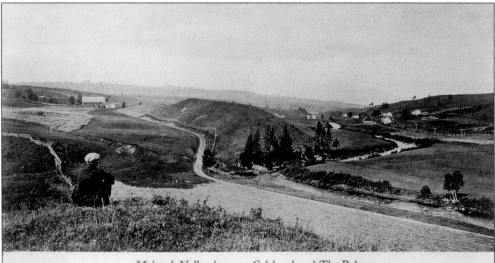

Mohawk Valley between Colebrook and The Balsams.

At 6:30 p.m., the collapse released Lake Abenaki and Lake Coashauk, sending a torrent down Mohawk Valley in an 800-foot drop in elevation toward Colebrook. The raging water swept through Kidderville five miles below the Balsams, wiping out the Washburn mill and dam. It destroyed farmland, ripped up houses, telephone poles, roads, and trees, and carried away cars, picking up thousands of tons of debris along its way. (CPL.)

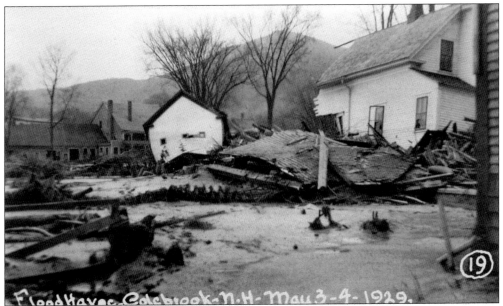

A 20-foot wall of water hit Colebrook at 8:00 p.m., heralding its approach with a deafening roar. Houses were floating on a crest of sea-like waves, reported *News and Sentinel* editor Harry Hikel. As daylight arrived, townspeople began sifting through the damage. Nearly every street had a dislodged house or barn sitting across it, but no lives were lost. (NS.)

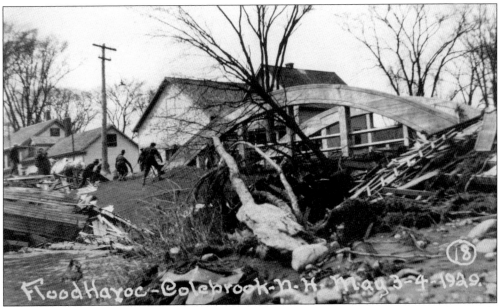

The flood tore out every bridge along the way and pushed the Parsons Street steel bridge, nearly the first structure to go in Colebrook, 500 feet away to Academy Street, where it fetched up against the Pleasant Street Bridge. As seen in this photograph taken by *News and Sentinel* editor Harry Hikel, the Pleasant Street Bridge held its ground. A total of 58 houses were impacted, with 25 homes moved from their foundations and 15 demolished. (NS.)

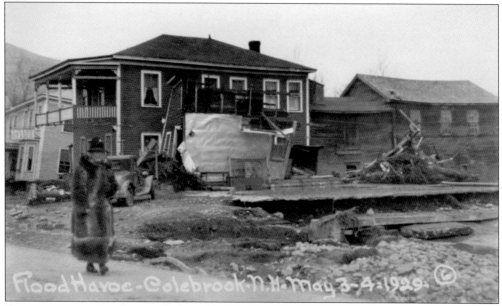

Damage was estimated at nearly $1 million, with the Colebrook Red Cross Relief Committee reporting 120 men, women, and children rendered homeless. $250,000 worth of roads had been turned into beds of boulders. Colebrook residents managed to keep their sense of humor, however. Arthur Sweatt, who cleaned up the flooded Colebrook House basement, said he caught 18 "good-sized" trout in the cellar. (SZ.)

Many members of the Colebrook Academy's class of 1929 lost homes in the flood. And a few months after graduation, they faced the Wall Street crash of 1929. Despite that, the class went on to great things. Graduates included several doctors, teachers, and New Hampshire's Rep. Marguerite Hughes Wiswell (second row, far left). They raised families and ran successful businesses throughout the hardships of the Great Depression and World War II. (SZ.)

A dozen years before the 1929 flood, in 1917, a Balsams dam broke, sending a torrent through the Archie Lyons farm and beyond. Edvina "Peanut" Lyons, who lives at this farm on Colebrook's Golf Links Road, said her husband's grandfather, Archie, heard a roar and called for his wife, Helen, to grab the children and head upstairs. Room-sized boulders demolished the downstairs, and the flood swept away their small dog, which returned two weeks later. (PL.)

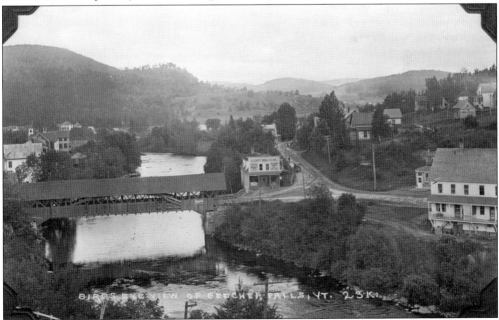

The Upper Coös Railroad opened in 1887 with 21.17 miles of track, four trestle bridges, five timber bridges, and eight highway crossings. This 1850 bridge, stretching from riverside in Stewartstown to Beecher Falls, was built by the Stewartstown Bridge Company and sold to George Van Dyke in 1887. After Van Dyke was paid, the bridge was toll-free. The Riverside Hotel is on the right, and the Elliot Drug Company is on the left. (CVHS.)

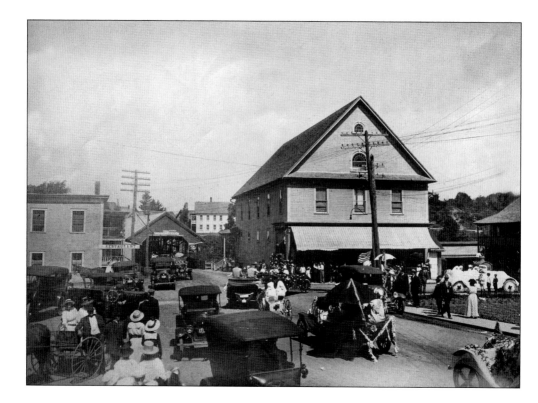

The Stewartstown Toll Bridge had a lot of customers at the 1900-era Fourth of July celebration above, with heavy traffic passing back and forth across the Connecticut River between Stewartstown and Canaan, Vermont. No doubt, the toll was suspended during this holiday. Loverin's store, with the Gem Theatre above it, is on the right in this photograph, with the Stewartstown House on the left. As shown by the ticket below, bought by William Trask from the Stewartstown Bridge Company, the toll in 1856 was $1.50 per year for a family. Covered bridges were once known as "spooning bridges" and were considered a perfect spot for a romantic interlude. This covered toll bridge collapsed in the early 1900s. Stewartstown resident Gary Richardson recalled that his grandfather Byron Stillings was the last to cross it. (Above, GR; below, NB.)

STEWARTSTOWN BRIDGE CO,

This is to let *Wm Trask* and family cross

STEWARTSTOWN BRIDGE for the year. *1856*

Received Payment.

$1.50

January 1st, 1856

James M Hill, Treasurer.

The Columbia toll bridge was built in 1844 by the Columbia Union Toll Bridge Company. Destroyed by heavy winds in 1891, it was rebuilt in 1892. That bridge burned in 1910. The third bridge was built in 1912 with no toll and then renovated and rededicated in 1981. In 1981, the first to drive across the bridge was Francis Brady of Columbia, in a Concord Coach. The bridge is listed in the National Register of Historic Places. (Above, TR; below, NB.)

Columbia Union Toll Bridge.

This Entitles _Jessie Cobell_

to the privilege of crossing COLUMBIA UNION TOLL BRIDGE during the present year, ending on the first Wednesday of April next, with his family; on his own business only; on condition that no one of them ride or drive on said Bridge faster than a walk.

It is also understood that the holder of this ticket shall pay an additional sum, to be adjusted by the directors, for hauling logs, wood, or lumber across this bridge.

CONDITIONS: FORFEITED IF TRANSFERRED.

D H Cook

B O Neil

E U Sims

Directors.

Columbia, N. H., April 5, 1905

Price $ 1.00

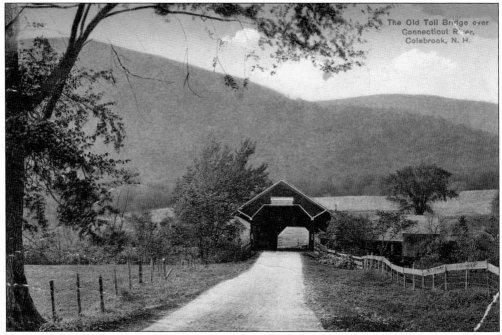

The Old Toll Bridge over Connecticut River, Colebrook, N. H.

The covered bridge above, once located at the end of Bridge Street in Colebrook, was built in 1854 by the Colebrook Bridge Company. It began as a toll bridge, but when it was sold and became the property of the town of Colebrook in 1881, passage was free. It was deliberately blown up in 1947, and replaced by the US Army Bailey Bridge. A steel bridge replaced the Bailey Bridge in 1952. Stewart Holbrook, an author who grew up in Lemington, Vermont, across the river from Colebrook, noted that this old bridge had watched men on foot, horseback, and stagecoach pass through "to die at Gettysburg and Cold Harbor." In 1917, automobiles went across with young men headed for the trenches of France. (Both, CHS.)

COLEBROOK TOLL BRIDGE.

This entitles *Joseph L. Kent* to the privilege of crossing Colebrook Toll Bridge, during the present year, ending on the first Monday of December next, with his family, on his own business, only ; on condition that no one of them ride or drive on said Bridge faster than a walk. And no one not known to the toll gatherer as belonging to the family, or on the business of the above named, is entitled to pass, unless he or she show this ticket or a line from the purchaser.

CONDITIONS :—

Directors.

COLEBROOK, N. H., *Dec* 18__

Price, $ 0.60

110

Eight

SLEDS AND SNOWMOBILES

Snowmobiling is a multibillion-dollar industry in the United States and Canada. With the decline of the paper industry, farming, and manufacturing, this sport is important to tourism, which now drives the economy of the Great North Woods. However, it was the region's inhabitants, not the tourists, who were the first enthusiasts, as shown by this snowmobiler at a race held at the Balsams Grand Resort in the 1960s. (PL.)

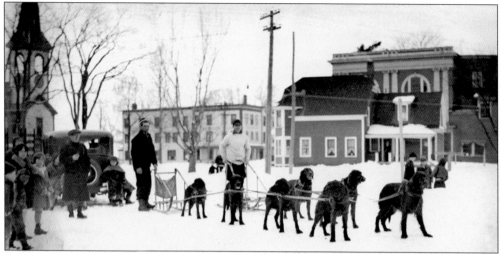

Before snowmobiles, dogsleds were often used for winter work. By the 1920s and 1930s, dogsledding was more for sport, and dogsled races were a big feature of the Colebrook Winter Carnival. Earl "Sliver" Bunnell, the barber in town, is credited with being the first dog musher in the world to race Irish setters. He came in second in the trials for the 1932 Olympics in Lake Placid, New York. (CHS.)

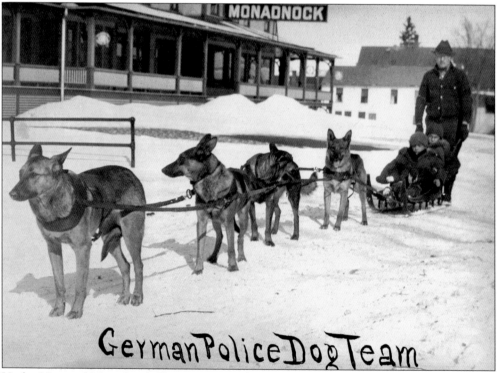

Harley Noyes of Monadnock House gives a ride to Frederick and Irving Noyes at the Winter Carnival. German Shepherds were among several breeds used by mushers. However, Earl Bunnell's team often proved faster than the Shepherds and even the Huskies. At the 1932 Olympic trials, he placed first in the initial 14-mile run, with his setters going past the lead Husky team "like a train," as one eyewitness reported. (CHS.)

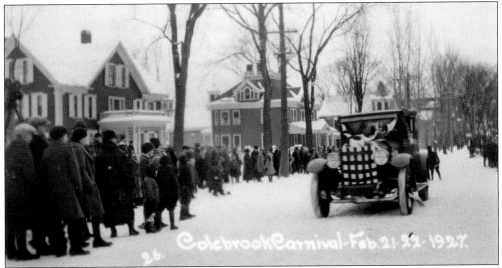

In the 1920s and 1930s, the Colebrook Winter Carnival was a two-day affair, with sled races drawing up to 12 teams and 2,500 spectators. Other activities included a parade, ski jumping, ice hockey, and theatrical productions. The Colebrook Winter Carnival is still held every February at the Colebrook Country Club, hosted by the Kiwanis. It is a one-day event, with a myriad of activities, including dogsled rides. (WW.)

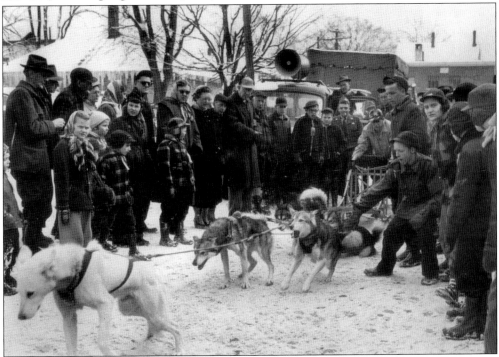

Local resident Bill Cummings recalls that area youth were fascinated with dogsled racing. He is the young man in the right forefront with the dogs. Earl "Sliver" Bunnell is the musher. Cummings's first race was in 1951. During one carnival, the play *Stalag 17* was being performed at the town hall. Cummings remembers driving his team into the hall, down the aisle, and out the door, to the audience's delight. (CHS.)

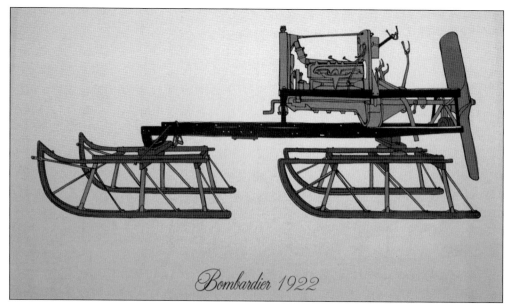

Bombardier 1922

Joseph-Armand Bombardier of Varicourt, Quebec, produced a light, motorized, sled-like snow machine for individual use, creating this prototype in 1922 at the age of 15. Prior to his and similar efforts, snow machines were workhorses, used by loggers and others needing to maneuver in deep snow. Alvan Lombard, born near Waterville, Maine, patented the steam Lombard log hauler in 1901, with steering skis and a track-support system. (LD.)

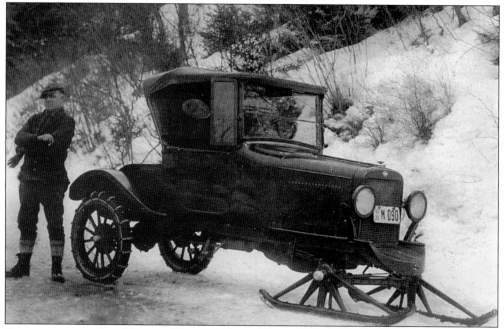

Stewartstown resident Norman Hunt stands with a Ford Model T White snowmobile. In the 1920s, Ford dealer Virgil White of West Ossipee, New Hampshire, began selling fully converted Model Ts and kits that converted the cars into what he patented as "the snowmobile." Baldwin Auto Company of Colebrook sold attachments and urged customers to "sell your horse and buy a snowmobile." (BU.)

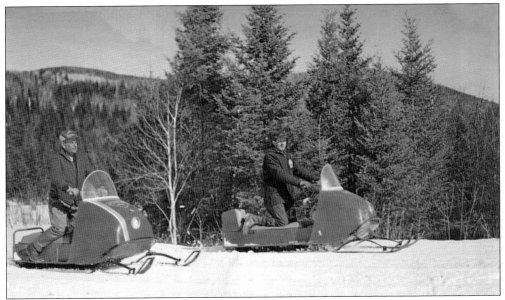

The Moto-Ski, with its metal cab, was produced in 1963. Herc Lemieux, seen here in the lead Moto-Ski, soon began selling them. Lemieux purchased his garage on Colebrook's Main Street in 1959 from the father of his wife, Pauline, Robert Spitzner, who had bought the garage in 1935. Pauline and the Lemieuxs' son Bobby are now part of Lemieux Garage Inc., a Ski-Doo and Can-Am dealership. (LG.)

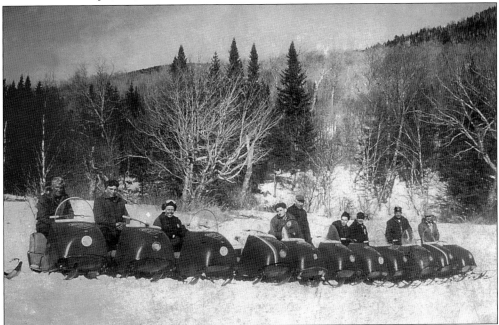

The Moto-Ski could go 35 miles per hour, but in pre-grooming days, the rate of speed was much slower. Snowmobilers usually traveled in groups to help break the trails. It took about eight hours from downtown Colebrook to reach this Swift Diamond River area, which now takes about an hour and a half. Here, Herc Lemeiux is fourth from the right, Claude Hebert is sixth from the right, and Peter Hebert is third from the left. (LG.)

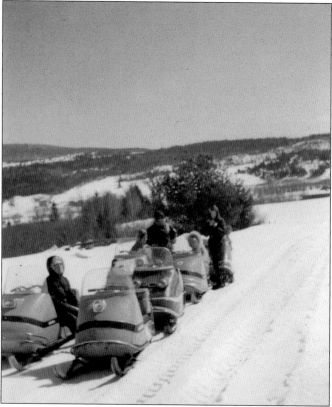

Edvina "Peanut" Lyons, who operated a Kidderville farm with husband, Richard, bought her first snowmobile in 1963. Peanut, who took the photograph, and her friends (from left to right) Janice Lyons, Betty French, Jeannette Ellingwood, and Virginia "Gige" Lay formed the Hardy Girls. Ellie Gooch was also a member. Preschool-aged Ronnie Lyons joined them on the weekly tours, calling them Yoo-Hoo Girls because of the way they called to each other on the trail. (PL.)

Lloyd Drew of Swift Diamond Riders, in his 1965 prototype Sno-Traveler, travels annually on an eight-day group tour from Millinocket, Maine. In 2011, Drew participated in the 50th anniversary ride, marking the Polaris Sno-Traveler's first northeastern test drive through Maine's Alligash Wilderness. The 1961 drivers competed against two dogsled teams, which they actually had to rescue. Drew's collection includes the Sno-Traveler that made the first snowmobile ascent of Mount Washington in 1963. (SZ.)

Groomer Harold Davis poses with the first Colebrook Ski-Bees groomer. The Ski-Bees, the first club in the area, incorporated in 1966. They established the first groomed snowmobile trail in the North Country, and dedicated part of the trail, now Corridor 18, to Kevin Haynes, the first to groom trails, using a bedspring. He was a hardworking proponent of snowmobiling in its early years. (CCC.)

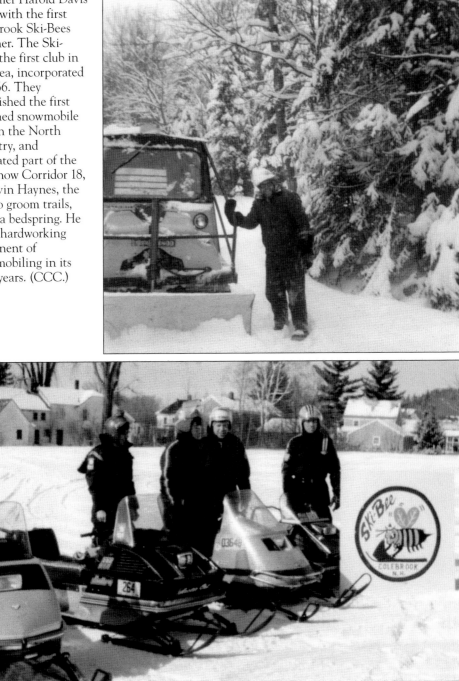

Since 1972, the New Hampshire Snowmobile Association has raised money for children with special needs with an annual Easter Seal Ride-In. In 1974, the Colebrook Ski-Bees participated in its first ride-in, traveling from the Colebrook Country Club grounds, seen here, to Lake Winnipesaukee in the Lakes region. From left to right are teenager John Mather, Yvonne and Bob Burrill, and Richard Lyons. (YB.)

Yvonne Burrill, who had driven a one-cylinder Arctic Cat without lights, poses with Boston Red Sox legend Carlton Fiske at Lake Winnipesaukee. Her group arrived after two days of rough riding over Gorham's Evans Notch and a night lake crossing of seven miles without their guide, who failed to show. Burrill recalls Colebrook friend Lucille Pike, who had feared the worst, breaking down in tears when they finally arrived. (YB.)

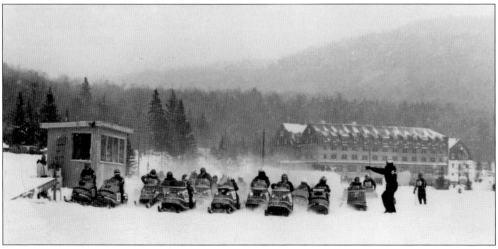

The Colebrook Ski-Bees organized races at the Balsams Grand Resort in the 1960s. Riders came from all around, with three local racers participating: Bruce Hawes, Claude Hebert, and Herc Lemieux. An awards banquet was held afterward. Club meetings were held for years at Hamp and Millie Roy's place, Sportsman's Lodge, in Stewartstown. Millie Roy, Peanut Lyons, and other members worked hard on club events, as do today's volunteers. (PL.)

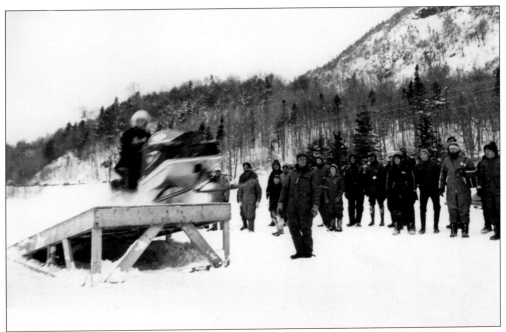

The Balsams races included jumps (above), which seem rather tame compared to the stunts at snowmobile events today. Still, there were spills on the oval track and on the jumps, resulting in injuries at times. The fierce winds and biting cold of Dixville Notch finally led to the end of the Balsams races. (PL.)

In 2003 and 2004, the Rock Maple Racing Snocross was held in Colebrook, hosted by the Ski-Bees. Columbia's Bungy Beavers, created in 1978, merged with the Ski-Bees in 1998. Club events raise funds for charity and proceeds also go toward the clubs' 40-percent share of the state's trail maintenance costs. Other off-highway recreational vehicle clubs, such as the Metallak ATV Club, formed in 2011, also contribute. (SZ.)

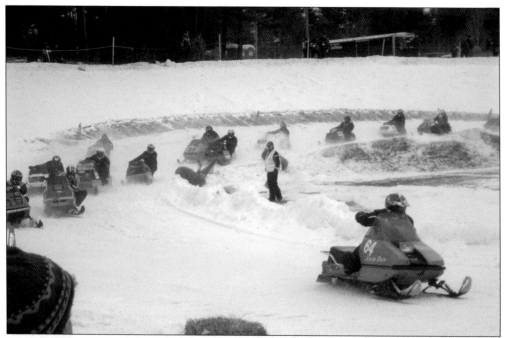

The Great North Woods Vintage Race Series is held from January through February and sponsored by LaPerle's IGA Plus. It is organized by the Colebrook Ski-Bees, the Pittsburg Ridge Runners, and the Umbagog Snowmobile Association. Entering its sixth year, this series is the only one of its kind in the Northeast. (JL.)

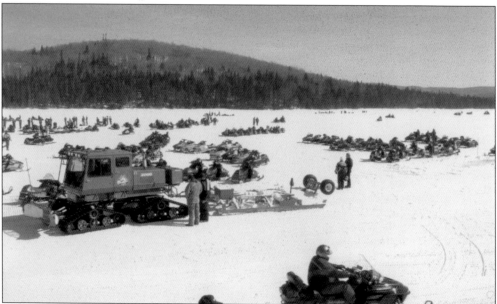

Stewartstown's Swift Diamond Riders Club draws thousands to the area by hosting the SnoDeo, held every March at Coleman State Park. Snowmobilers can test-drive new Polaris, Ski-Doo, Yamaha, and Arctic Cat models, as well as Can-Am all-terrain vehicles. Snowmobilers often ride in from the trails and enjoy a host of activities. The Swift Diamond Riders clubhouse, adjacent to Coleman State Park, is considered the best in the state. (SDR.)

Nine

GOING TO THE MOVIES

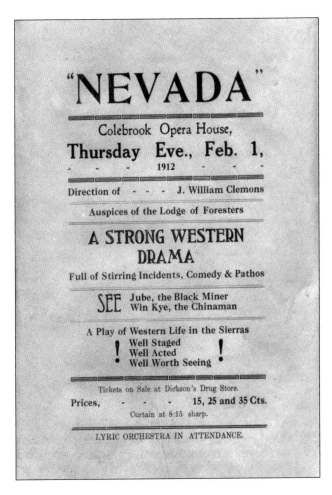

"NEVADA"

Colebrook Opera House,

Thursday Eve., Feb. 1,
1912

Direction of - - - J. William Clemons

Auspices of the Lodge of Foresters

A STRONG WESTERN DRAMA

Full of Stirring Incidents, Comedy & Pathos

SEE Jube, the Black Miner
 Win Kye, the Chinaman

A Play of Western Life in the Sierras
! Well Staged !
 Well Acted
 • Well Worth Seeing •

Tickets on Sale at Dickson's Drug Store.

Prices, - - - - **15, 25 and 35 Cts.**
Curtain at 8:15 sharp.

LYRIC ORCHESTRA IN ATTENDANCE.

Before moving pictures, there was the theater. There were several theaters in the region, including the Colebrook Opera House, which had been the second town hall on Bridge Street, built after the first town hall burned in 1870. That building burned in 1938 and was replaced by the present town hall. It was the setting for the performing arts and dancing. (NB.)

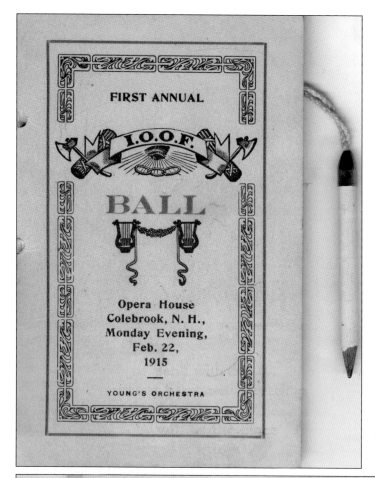

FIRST ANNUAL

I.O.O.F.

BALL

Opera House
Colebrook, N. H.,
Monday Evening,
Feb. 22,
1915

—

YOUNG'S ORCHESTRA

The Independent Order of Odd Fellows (IOOF) local chapter held its first-annual ball at the Opera House in 1915. The order was founded in 1819 in Baltimore by Thomas Wildey. It developed into a family fraternity that aimed to serve the community. The young lady's dance card below has only two dances filled in: the Waltz and the Plain Quadrille. "N.J.B.," no doubt her beau, apparently lacked the confidence to fill in all the dances. They included the Boston Fancy, the Galop, the Five-Step, and the Lanciers Quadrille. The contra dance, which includes steps like the Boston Fancy, done with couples in two facing lines, is still popular today. (Both, NB.)

Order of Dances

Grand March and Circle
Waltz :

Plain Quadrille

Two-Step

Boston Fancy

Five-Step

Galop

Lanciers Quadrille

Waltz *N. J. B.*

Intermission
Supper at the Monadnock

Waltz One-Step Five-Step

Portland Fancy

Waltz

Plain Quadrille *N. J. B.*

Galop

Five-Step

Two-Step

Waltz

Extras

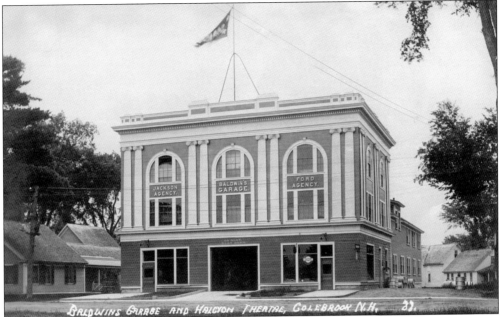

The first silent movie at the Halcyon Theatre (now the Family Dollar Store and Lin-Jo's Creations) was *The Prisoner of Zenda*. In 1913, Frank Baldwin constructed the Baldwin Garage, with the 550-seat Halcyon Theatre above it. The first "talkie" arrived in 1930. Arthur Sweatt recalled that the first movie he saw was *High Blue Society*. Sweatt, a teenager working in Averill, Vermont, traveled by the only means he had, his feet, running 15 miles to see the film. (NB.)

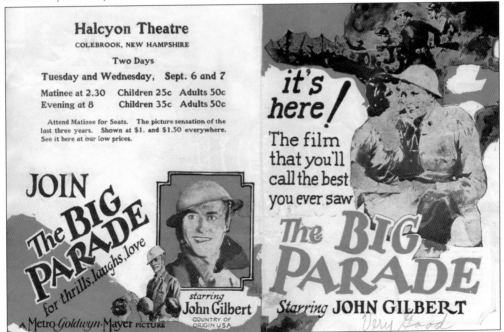

Silent screen star John Gilbert's career did not survive the talkies. One of his best roles had been as a doughboy in *The Big Parade*. It was considered Hollywood's best World War I epic, directed by King Vidor. Gilbert, battling alcoholism, died in 1935 at only 37 years of age. (CF.)

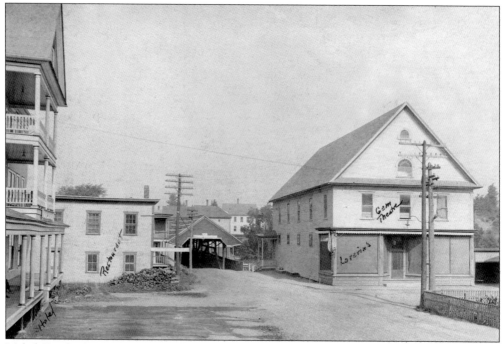

Mabel Caird, who grew up across the river from West Stewartstown, became a devoted fan when the silver screen arrived at the Gem Theatre. The Gem was above Loverin's store, where Solomon's is now. During Caird's youth in the Roaring Twenties, the two standard seat prices were 10¢ and 25¢. Her family still has the 60 playbills she kept as a souvenir of her starstruck years. (BU.)

The Gem Theatre was the scene of many theatrical efforts. "Pete" Merrill (second from left) and her husband, Lew, (eighth from left), the town's pharmacist, were among those who enjoyed play-acting. Alice Moore (seated, far right) was the pianist for many productions. Moore was also the pianist for the silent movies. She did a good job keeping up with the action, according to Arthur Sweatt. (BU.)

124

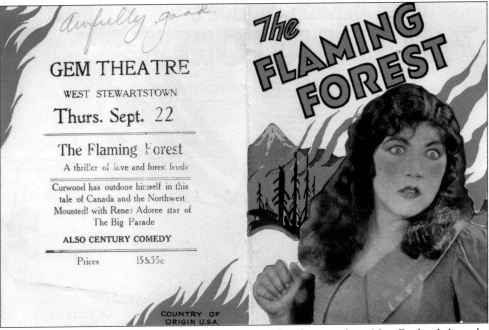

Theater managers sought to find films that would appeal to their northern New England clientele. *The Flaming Forest*, released in 1936, was a film bound to please. The drama's center was a forest fire, a subject close to this logging community's heart. It starred Antonio Moreno and Renée Adorée, who had also starred in *The Big Parade*. (CF.)

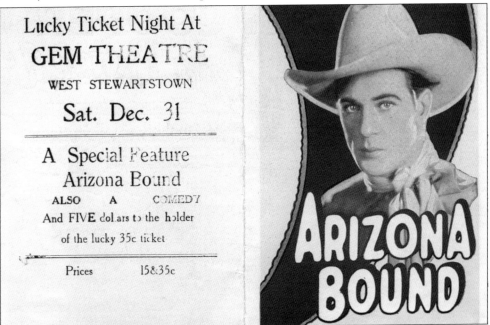

Gary Cooper played a bit role in *Beau Geste* and starred in the silent Western flick *Arizona Bound*. He survived the advent of the talkies, which was not much of a stretch for this actor, who made a career out of playing the strong, silent type. For *Arizona Bound*, he was billed as "a man who can do anything with a horse except make it play marbles." (CF.)

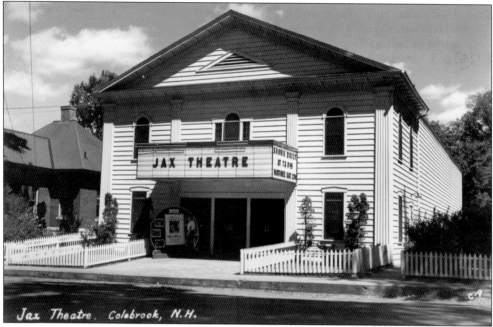

The Halcyon Theatre closed on August 29, 1938, and the Jax Theatre opened on September 1. Built by John Eames, the new theater had more than 500 seats. The arms of two seats were removed for hefty Samuel Weeks, of Weeks Tavern, who bought the first ticket. The Jax closed in 1971, and the building now houses the state liquor store. The piano used for silent movies at the Halcyon is now at Colebrook's Great North Woods Interpretive Center. (NB.)

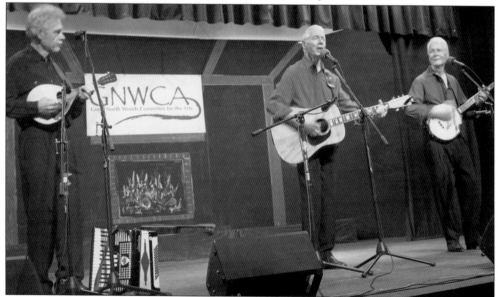

Today, theatrical productions and other entertainment abound at Colebrook's Tillotson Center. In October 2012, the Shaw Brothers, once part of the Hillside Singers, who performed the 1970s hit version of *I'd Like to Teach the World to Sing*, returned to their hometown for a concert. Born in West Stewartstown, brothers Rick (center) and Ron Shaw (right) were joined here by Taylor Whiteside (left). (SZ.)

BIBLIOGRAPHY

Columbia Historical Committee. *History of Columbia, New Hampshire 1770–2009*. Columbia, New Hampshire: Columbia Historical Committee, 2009.

Gifford, William H. *Colebrook: A Place Up Back of New Hampshire*. Colebrook, New Hampshire: News and Sentinel, Inc., 1990.

Gove, William. *Logging Railroads of New Hampshire's North Country*. Willamstown, Vermont: self-published, 2010.

Holbrook, Stewart H. *Holy Old Mackinaw: A Natural History of the American Lumberjack*. New York City: Macmillan Company, 1938.

———. *The Story of American Railroads*. Bonanza Books, 1947.

———. *Yankee Loggers*. International Paper Company, 1961.

Hulse, Granvyl Jr. *From the Prisoner of Zenda to Machine Gun McCain: Colebrook's Love Affair with the Movies*. Colebrook, New Hampshire: self-published, 2007.

Ingham, Alister. *As the Snow Flies: A History of Snowmobile Development in North America*. Lanigan, Saskatchewan, Canada: Snowmobile Research Publishing, 2000.

Leavitt, Richard. *Colebrook Yesterday*. Colebrook, New Hampshire: self-published, 1970.

Merrill, George. *History of Coös County, New Hampshire*. New York City: W.A. Fergusson, 1888.

Nilsen, Kim. *The Cohos Trail*. North Hampton, New Hampshire: Nicolin Fields Publishing, 2010.

Piotrowski, Thaddeus. *The Indian Heritage of New Hampshire and Northern New England*. Jefferson, North Carolina: McFarland and Company, 2002.

Stewartstown Day Committee. *Stewartstown Memories*. Stewartstown, New Hampshire: Stewartstown Day Committee, 1976.

Zizza, Susan. *Turn of the Twentieth: Early 1900s Northern New England through the Lens of Photographer Glenduen Ladd*. Colebrook, New Hampshire: self-published, 2007.

ABOUT THE AUTHOR

Susan Zizza began a publishing career in 1986, serving as an editor and photojournalist for the *News and Sentinel*, the *Colebrook Chronicle*, and *Northern New Hampshire Magazine*. She has been a freelance writer since 2003, with her work appearing in *Vermont Life* and *New Hampshire ToDo*, among other publications. She is the author of *Turn of the Twentieth: Early 1900s Northern New England through the Lens of Photographer Glenduen Ladd* and a contributing author of *Beyond the Notches*. She and her husband, Mark, have resided in Colebrook since 1977, where they raised two sons. Zizza is descended from the early settlers of the region.

DISCOVER THOUSANDS OF LOCAL HISTORY BOOKS
FEATURING MILLIONS OF VINTAGE IMAGES

Arcadia Publishing, the leading local history publisher in the United States, is committed to making history accessible and meaningful through publishing books that celebrate and preserve the heritage of America's people and places.

Find more books like this at
www.arcadiapublishing.com

Search for your hometown history, your old stomping grounds, and even your favorite sports team.